EXPANDING Walking Bass Lines

By Ed Friedland

Cover photos courtesy of CARVIN.
Photo of Ed Friedland by Jean Hangarter.

ISBN 0-7935-4586-2

7777 W. BLUEMOUND RD. P.O. BOX 13819 MILWAUKEE, WI 53213

Copyright © 1996 by HAL LEONARD CORPORATION
International Copyright Secured All Rights Reserved

No part of this publication may be reproduced in any form or by any means
without the prior written permission of the Publisher.

Table of Contents

Preface .4
Goal Statement .4
Acknowledgements .4
About the Author .4
Using the Audio .5
Fine Tuning Your Time Feel .6

Part One

Overview .9
A Disclaimer .9
Introducing Rhythms .9
Eighth Note Triplets .11
Rests .11
Combining Rhythms and Rests .13
Adding Rhythmic Embellishment .14
More Practice with Skips .14
Skips with Dead Notes .15
Lift-off Dead Notes .16
Putting It Together .17
Using Triplets .18
Even More Triplets .19
Triplets with Dead Notes .22
Expanding the "Two" Feel .24

Part Two

Overview .26
Targeting Non-chord Tones .26
Using Scale Tones as Targets .27
Using Chromatic Passing Tones as Targets .30
Interpreting Chord Symbols with Tensions .32
Playing Over Modal Tunes .33
Create Your Own Modal Map .37
Pedal Points .38
A Listening Assignment .40
Walking Open: The Art of Implied Harmony .40
A Closing Word .42

Appendix

Using the Appendix .43
Tune 1: ABAC form .44
Tune 2: "Rhythm Changes" A section .45
Tune 3: Several Key Centers in A section .46
Tune 4: "Expanded Two Feel" .47
Tune 5: Modal .48
Tune 6: Bridge Modulations .49
Tune 7: Repetitive A section .50
Three Mystery Tunes .51
Things to Consider .51
Things You Should Know .52
Things You Can Do .52
Notation Legend .54

Preface

In the first book of this method, *Building Walking Bass Lines*, we learned many of the basic skills needed to create good, solid lines from a set of chord changes. The techniques discussed were: finding the root motion, adding the fifth, approach techniques (chromatic, dominant and scale), scale wise motion, resolving to chord tones other than the root, arpeggiation, indirect resolution, and chromatic motion.

If you are not familiar with these concepts, I recommend you use *Building Walking Bass Lines* before attempting to work through the material in this book. It is crucial to your understanding to have a good foundation with the rudiments of walking. The information presented in this book will be most useful to those who have a firm grasp of these basic skills.

Goal Statement

This book will expand on your knowledge of the basics by focusing on some of the finer points of walking bass lines. You will be exposed to some practical concepts to help you become more functional in a jazz rhythm section. We will branch out from the "straight ahead" and learn to stretch the boundaries of tonality. It is also a goal of this method to provide you with an opportunity to experience some "real world" situations and develop the skills to cope with them.

Acknowledgments

Thanks to my family. Sonia, LeeEllen and Aimee Friedland, and David Taylor. Thanks also to Jim Roberts at *Bass Player Magazine*, Larry Fishman of Fishman Transducers, Bill Brinkley, Michael Merrill, Tom Hamilton, Athena, Lu Ann, Ed Siegfried, Dave Flores, and everyone at Carvin, and GHS strings.

About the Author

Ed Friedland is a graduate of the High School of Music and Art in New York City, and a former faculty member of Berklee College of Music and Boston College. He is a frequent contributor to *Bass Player Magazine*. His performance credits include Larry Coryell, Michal Urbaniak, Robben Ford, Mike Metheny, Johnny Adams, Linda Hopkins, Robert Junior Lockwood, Barrence Whitfield and the Savages, Martha and the Vandellas, The Drifters, Brook Benton, the Boston and Tokyo productions of *Little Shop of Horrors*, the Opera company of Boston, and the Boston production of *A Closer Walk with Patsy Cline*. Ed is involved in producing and arranging with Bass Station Music. He has a M.Ed. from Cambridge College, Cambridge, Massachusetts. He uses Carvin basses, GHS strings and Fishman transducers. Ed resides in Tucson, Arizon.

Photo: Jean Hangarter

Using the Audio

The audio portion of this method is of equal importance to the text, since learning to walk without the opportunity to hear the lines is an incomplete experience. In view of the scarcity of clubs around the world where you can go sit in and experiment, I have provided an alternative. However, if you have the opportunity to play at a jam session, or do a jazz gig, by all means take it. There is no replacement for the actual experience of playing in a live rhythm section. I hope you will get to play with players as great as the ones I hired for this recording, Brad Hatfield on piano and Jim Lattini on drums.

This method's audio uses a split-stereo mix with piano and drums on the left channel, and bass and drums on the right channel. This configuration will allow you to turn off the bass track and play with the piano and drums. It will also make it easier to hear the bass track when learning the lines by ear, and transcription.

The examples in the book marked with a CD **1** icon have a number that corresponds to the number on the audio. The example number is given and then counted off with a click. The click is a two measure count off, two half notes, and three quarter notes, leaving beat four of measure two blank. For example: 1...2...1, 2, 3, ...(play).

There are many opportunities in the book to create your own lines. These are the examples with chord symbols and slashes without a specific written bass line. It is more common for the bass player to encounter this type of reading in the real world, so these examples are very important. The bass lines for these examples are not written in the book, so they provide an excellent opportunity to practice learning by ear. Go the extra mile and transcribe these bass lines. Writing music on paper is one of the best ways to improve your ability to read music. Remember, you can use any of the chord progressions presented to practice any technique learned. If you want to practice fingered triplets with a progression from another part of the book, go ahead.

The last section of the book, the Appendix, includes ten jazz progressions. The last three progressions have no chord changes written. These "mystery tunes" are included to provide you with the challenge of learning a song completely by ear, with no prior information given. As difficult as this may seem, thousands of bassists do it all the time. "Faking" tunes is an important skill that bass players must have to survive in the real world. It is not my intention to have this book become a full-scale primer of all the background information one needs to develop this skill; that comes from years of experience. There are suggestions given to help you develop an awareness of the process, things to listen for, hints about form, but nothing concrete. This process is more like sorcery than science.

This book will not guarantee your ability to swim when you're thrown into the deep end of the pool, but it may save you from drowning! Stick with it, give it time, and keep your ears open!

Fine Tuning Your Time Feel

Those familiar with *Building Walking Bass Lines* will recall a page titled "Top Priority." On this page I explained why keeping time is the first responsibility a bassist must shoulder. (If you're not aquainted with that page, perhaps you should seek it out.) At this point I will assume that if you are prepared for the material in this book, you are already aware of the need to keep solid time and have put in considerable work toward achieving that goal. Just in case, I felt it wise to include this set of exercises.

This group of "metronome rituals" is an excerpt from an article I wrote for *Bass Player Magazine* entitled "The Metronome As Guru" (Bass Player April, 1993). We will use a one octave major scale so you can focus on the time and not what notes to play. Later, you can substitute walking lines if you like.

The first example uses the click on beats 2 and 4. This will help you develop your swing feel. The classic approach for the 4/4 jazz feel has the drummer using the hi-hat on 2 and 4. When you play with the drums, listen to the hi-hat for the anchor. The ride cymbal will be playing quarter notes and breaking up the beat, propelling the groove. The snare is used to accentuate different melodic rhythms. The kick drum adds emphasis to the overall phrasing of the drum patterns. The hi-hat is where it all locks in. Pay attention to it. Use the metronome to simulate the hi-hat, and imagine the rest of the drum set while practicing. Follow these steps:

1. Turn on metronome.
2. Tap your hand on the beat.
3. While your hand is in the air, start counting on beat 1.
4. Your hand should now be coming down on beat 2.
5. Keep this up until you feel the groove, then start playing.

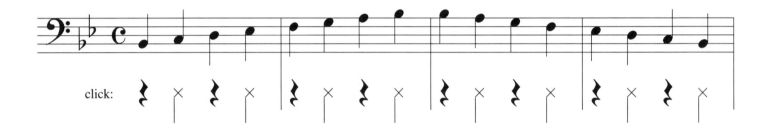

The next set of exercises will make you concentrate on the beat in a different way. There will only be one click per measure, first on beat 1, then beat 2, then beat 3, and then beat 4. The key is to keep the first beat feeling like the downbeat, even when the click is on another beat.
1. Start slow, use the metronome at 40 beats per minute.
2. Get the pulse by counting 4 notes per click.
3. Make the click the downbeat by starting your count on beat 1.

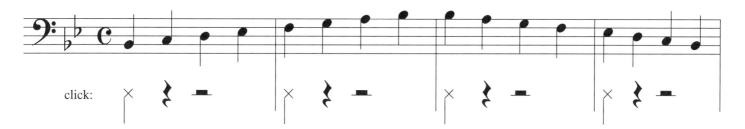

1. Start counting on the click, but begin your count on beat 2: "2, 3, 4, 1, 2, 3, 4…"
2. Once you feel comfortable with the count, shift the accent of the count to beat 1: "*1*, 2, 3, 4, *1*, 2, 3, 4…"
3. Make sure the click is still on beat 2. When you can feel beat 1 as the downbeat, start playing the scale. Focus on the groove it creates.

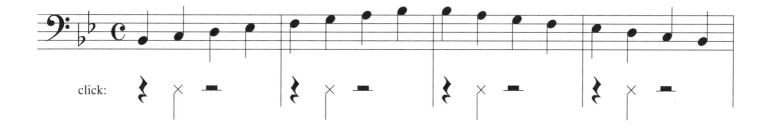

This exercise should feel natural, it's a half-time back beat.
1. Start counting on the click: "3, 4, 1, 2, 3, 4…"
2. Shift the accent to beat 1, keeping the click on beat 3: "*1*, 2, 3, 4, *1*, 2, 3, 4…"
3. When you feel locked in to the groove, start playing.

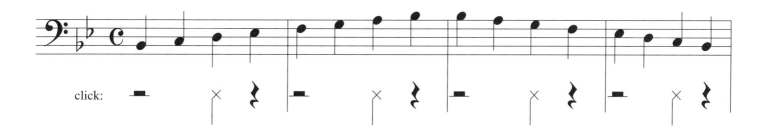

This one is tricky, but not impossible.
1. Start your count on beat 4: "4, 1, 2, 3, 4, 1, 2, 3, 4..."
2. Shift the accent to beat 1: "*1*, 2, 3, 4, *1*, 2, 3, 4..."
3. You can also get into this one by starting your count after the click, "click, 1, 2, 3, 4, 1, 2, 3, 4..."

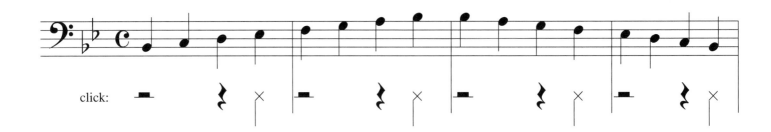

These are very powerful rituals for developing your own sense of time. Play them slowly and build up to faster tempos. Never sacrifice accuracy for speed. Wait until you feel locked in with the click before you start playing.

PART ONE

Overview

In the first part of this method, we will learn how to use rhythmic embellishment to add interest to our bass lines. We will first learn to interpret the rhythms without any pitches applied to them. Then we will move on to the various techniques of rhythmic embellishment: skips, skips with dead notes, skips using adjacent strings and an assortment of applications of the triplet. Next, we will learn how to expand on the "two" feel. This basic concept comes to life when we tastefully apply rhythmic activity.

A Disclaimer

The written examples are designed to showcase the technique currently being discussed. Because each example is limited in length, the technique may be used more frequently than in a standard performance. Care has been taken to keep the examples within the realm of musicality, however, in my opinion, the given techniques are most effective when used sparingly.

Introducing Rhythms

As we expand our knowledge of walking bass lines, we will start to add the rhythmic embellishments you hear accomplished bassists use. Skilled bassists use skips and triplets to add interest to a line, help define the feel with greater clarity, and create places for the bass line to "shine through" while still remaining in the role of accompanist.

Before we can start to use these devices effectively, we must first understand the rhythmic material that is used to create them. While a walking bass line primarily consists of quarter notes, we will now use eighth note triplets in various configurations to add a new dimension to the line.

We will learn about all the levels of rhythmic activity up to the eighth note triplet. Although there are many other rhythms, as a bassist playing swing oriented music, you will not need anything smaller too often. These examples represent a fraction of the rhythmic training you need to be a great bassist. For a more complete work through I recommend *Modern Reading Text in 4/4* by Louie Bellson and Gil Breines (Bellwin Mills Publishing).

How we count the smaller rhythms is important. Eighth notes are counted "1-and (+), 2-and, 3-and, 4-and." Eighth note triplets are counted "1-and-a, 2-and-a, 3-and-a, 4-and-a."

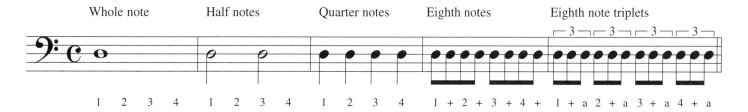

The first rhythm we will explore is the eighth note. Underneath the first two measures of this example is the counting pattern. The symbol (+) means: count the "and" of the beat, but don't play it. It is important, at first, to keep track of the eighth note pulse in order to keep your place in the measure. All the rhythmic exercises should be practiced with the metronome. Start with the click on quarter notes. When you are comfortable with that, play them with the click on beats 2 and 4.

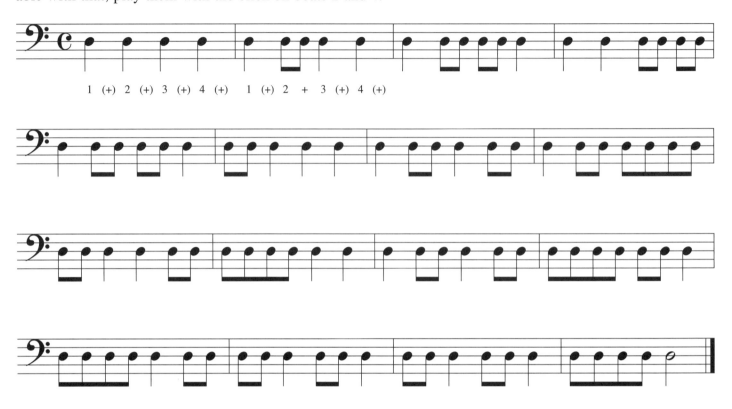

The next example demonstrates eighth note syncopation. Syncopation occurs when the upbeats ("ands") are emphasized and the downbeats are silent. Syncopation is a major part of the rhythmic concept of jazz. As before, (+) means: the "and" is counted but not played. You will also see numbers written this way, "(2)." This means: the downbeats are counted, but not played.

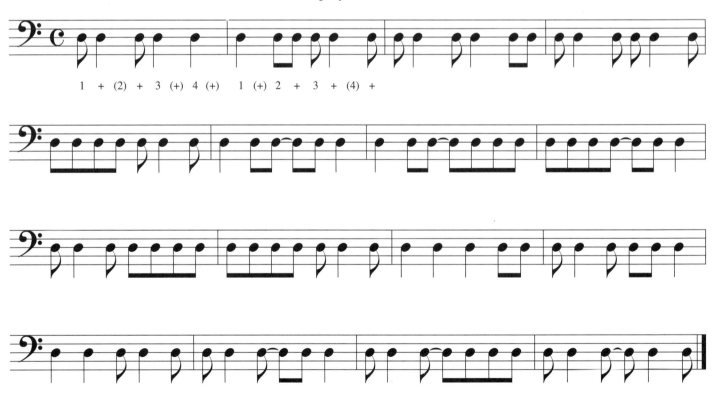

Eighth Note Triplets

The next rhythm we need to learn is the eighth note triplet. This rhythm squeezes three eighth notes into the space of one quarter note. Eighth note triplets are the underlying pulse of swing based jazz, so it is very important to develop a feel for them.

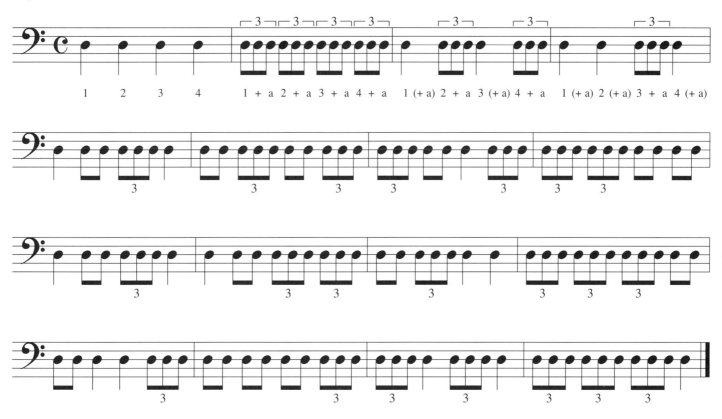

Now we will take the first two beats of the triplet and tie them together. You will play on beats 1 and 3 of the triplet, letting beat two be silent. This rhythm is the basis of the swing feel on the ride cymbal.

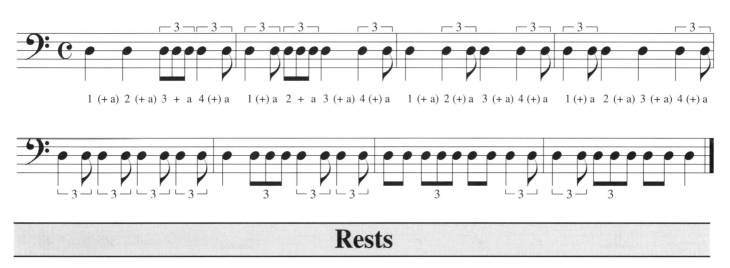

Rests

For each rhythmic note value there is a corresponding rest. These rests are spaces in which no sound occurs, yet they must be felt as the exact length of the note they replace, otherwise the measure will not be the proper length.

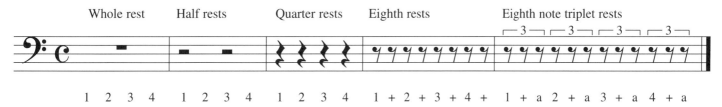

Here is an example of quarter and eighth note rests. Remember to keep feeling the pulse through the rests. Pay attention to the length of notes before a rest — don't let them ring through the space.

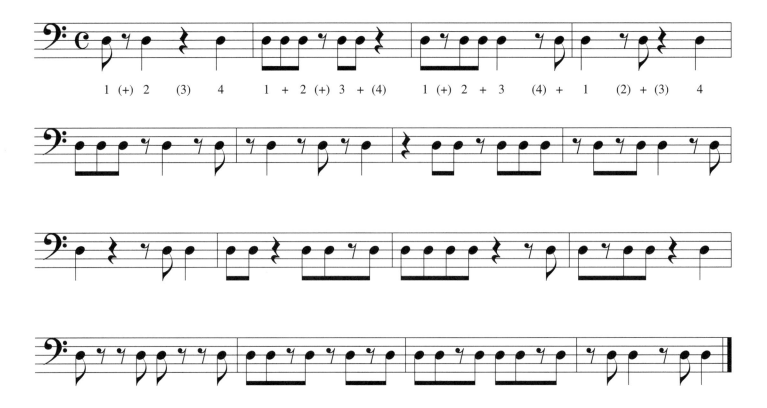

This example uses eighth note triplets and rests. As we start to embellish the walking bass line, we will use the triplet in a few different configurations. These examples will help you develop a feel for the different ways the triplet can be broken up. Practice each one in a loop until you feel comfortable. The triplet has a rounded, wave-like quality to it. Let it roll!

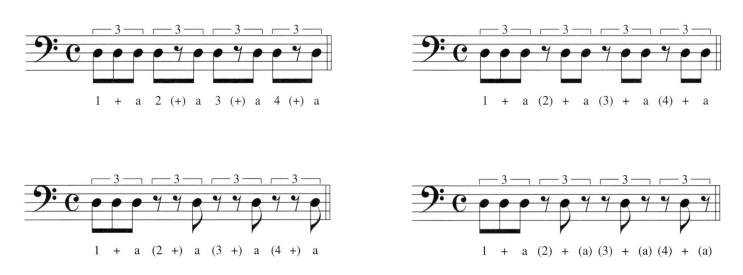

After spending some time with these rhythms they start to feel natural. They are important elements of the swing feel. Even when you are only playing quarter notes, these rhythms are happening all around you in the drum, keyboard, guitar and horn parts. Understanding them helps solidify your walking feel, as well as giving ideas for rhythmic embellishment.

Combining Rhythms and Rests

Now we will combine quarter notes, eighth notes, eighth note triplets and their corresponding rests. This example is a representation of the type of rhythmic activity found in jazz. These rhythms are commonly used by drummers on the ride cymbal and snare drum. The ride cymbal and the bass line are very closely linked. When listening to a great jazz rhythm section play together, pay attention to how the ride cymbal and the bass line are connected. When a bassist and drummer really hook up, it's as if they are breathing together.

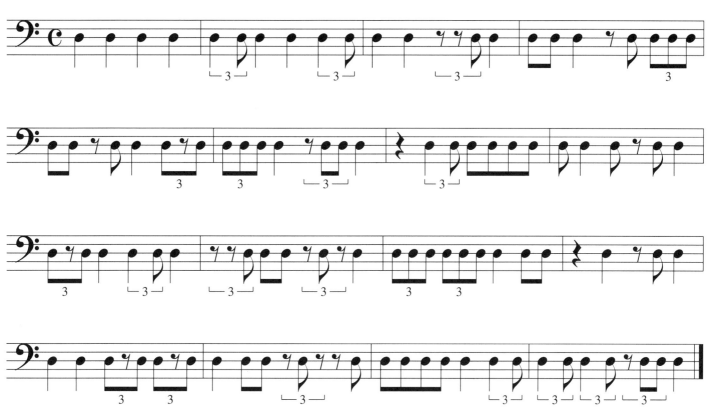

Next we will add rhythmic embellishment to the walking bass line, but first, let's tune up!

 Tuning note G.

Adding Rhythmic Embellishment

Having gained familiarity with the essential rhythms of jazz, we will now add them to the walking line for some variety and flavor. However, just like spice, a little goes a long way, and too much is unappetizing. All too often, bassists try to use these devices before they are well grounded in the quarter note pulse. The end result is a bass line that is too busy, doesn't swing, and often, a bass player losing a gig. Remember, we are primarily in the rhythm section to *support* the other musicians, to outline the changes, and to groove, groove, groove! Too much embellishment is obnoxious! Having said this, let's learn how to play lots of notes.

The first embellishment we will use is the skip. Skips are broken triplet rhythms that accentuate beats 1 and 3 of the triplet. The skip adds a bounce to the line that can be very effective when used economically. Put a slight emphasis on the second note of the skip, this keeps the momentum of the line moving forward.

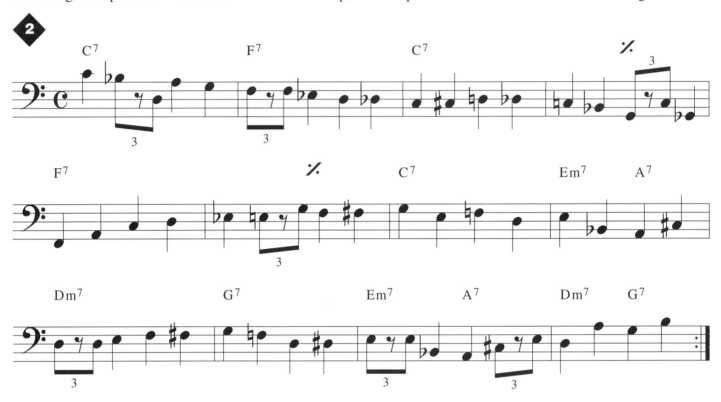

More Practice with Skips

Here is another example of the skip in action. Notice that it can be used on any beat of the measure. It can be played on the same note, or within the given chord structure, or used to outline a resolutional pattern.

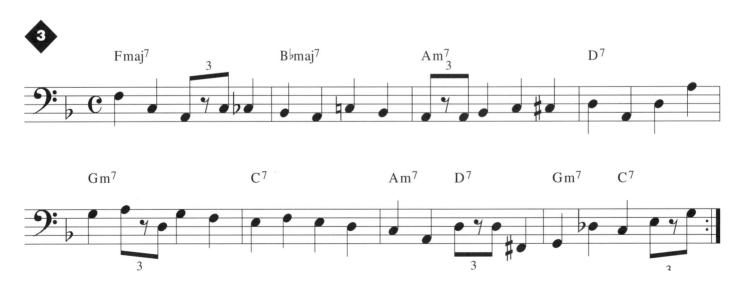

Here is your chance to put this idea to work for you. Use it sparingly at first, then add more. Experiment. Experience for yourself how it feels to overuse an idea, then compare it to using less. When you've done all that, transcribe the bass line from the CD.

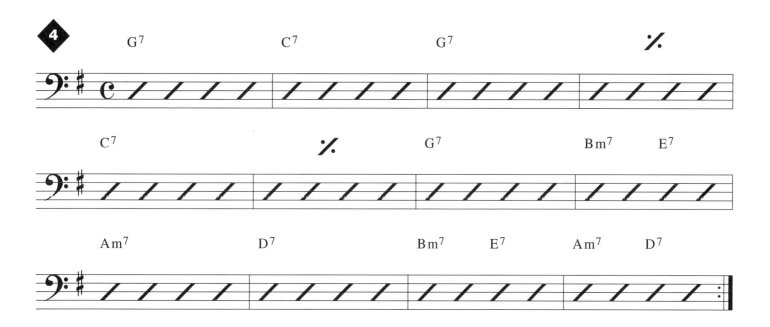

Skips with Dead Notes

A dead note is a muted pitch that creates a percussive effect. This variation of the skip uses a dead note on the skip beat to create a percussive effect. If you are playing the dead note on the same string as the previous note, you can simply take some of the pressure off the note, staying in contact with the string. If the dead note is to be an open string, mute it with your left hand. If you play a dead note on an adjacent string, strike the first note with the second finger of the right hand, then play the skip note with your second finger after which you quickly cut off the pitch with the first finger. Remember, rhythmic accuracy is very important. The groove must not suffer due to added rhythmic activity.

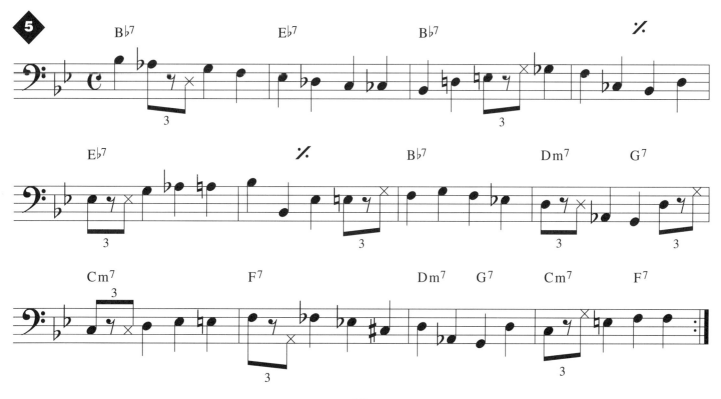

This next example is designed to work on the dead note skip on an adjacent lower string. Deaden all the open strings with the first finger of the right hand. Experiment with different levels of muting: some notes can have more pitch than others.

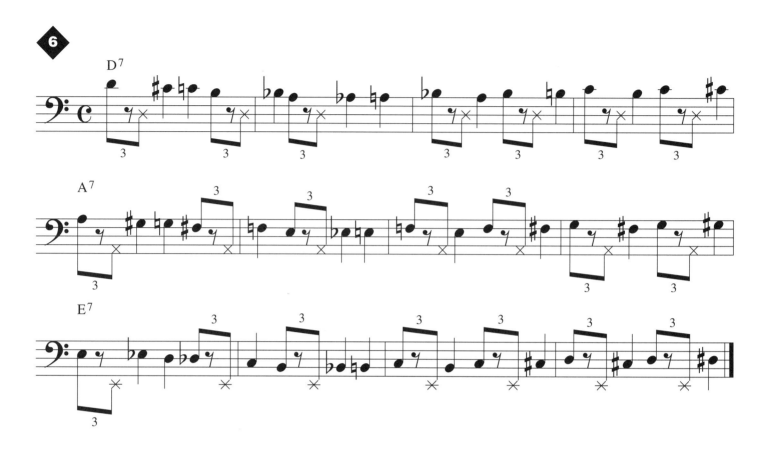

Lift-off Dead Notes

Another technique is called the lift-off. This is done by playing the first note of the skip, then pulling off the string with the left hand. You actually pluck the string as you take the finger off (notated with an "L" underneath). This gets the open string to sound, which is immediately muted with the right hand. It works especially well on the upright bass.

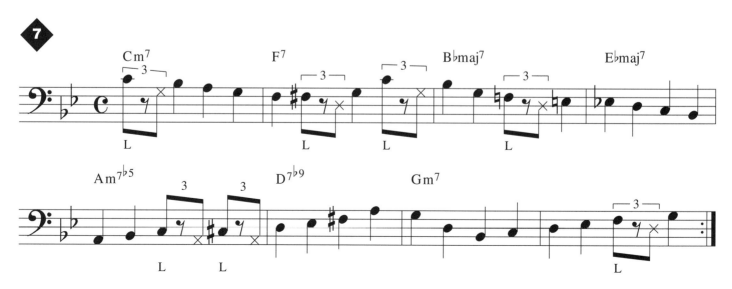

Putting It Together

Now we will put together all the different kinds of skips to create a line with more variety and interest. After you've learned to play the written line, read just the changes and play your own.

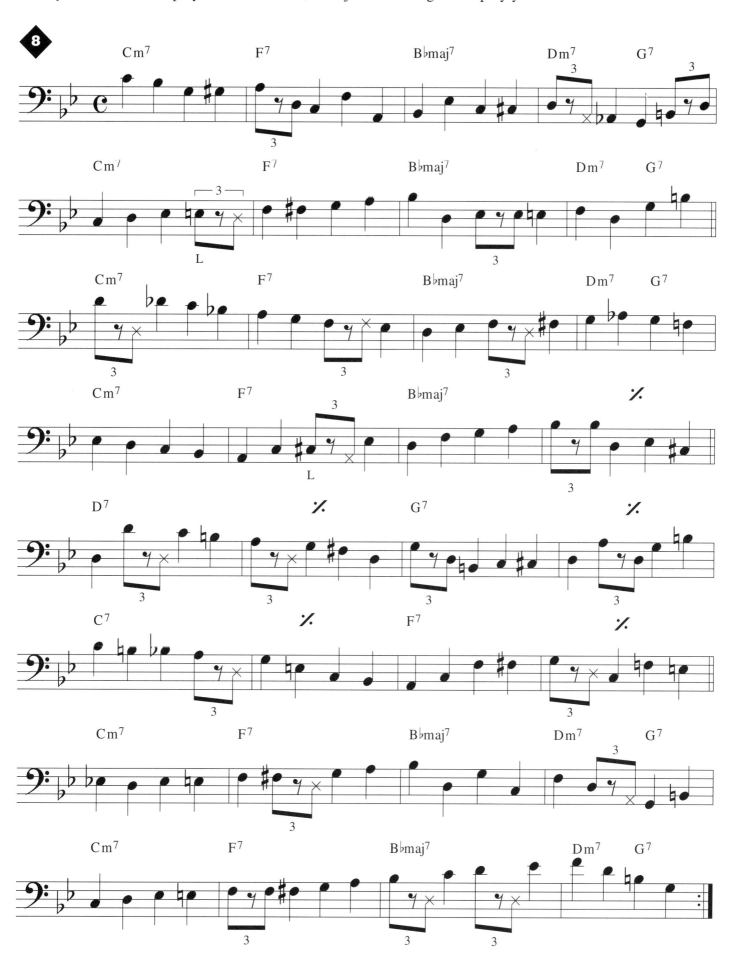

Using Triplets

There are several ways to play the triplet embellishment, each with it's own particular feel. First we will look at the fingered triplet. Each note in this triplet is an actual pitch. There are several ways to articulate this embellishment. On all these triplets, put a little emphasis on the last beat (tri-pul-*let*) to give it a little top spin.

First we have triplets that use the root, fifth and octave. First descending, then ascending.

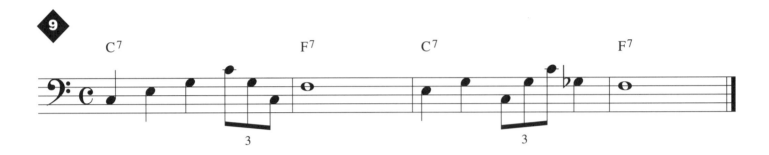

These use the flat seventh…

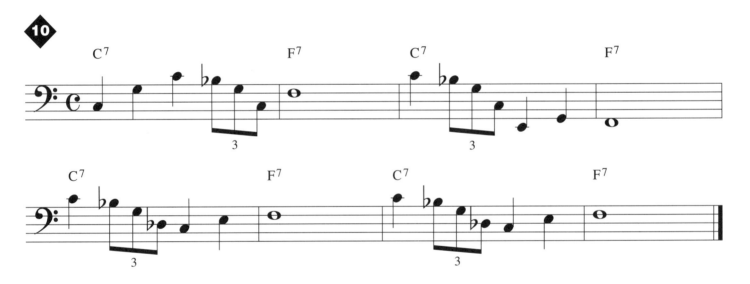

This next group uses ascending and descending arpeggios for the triplet.

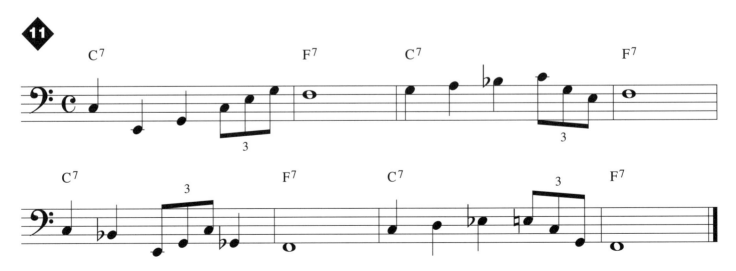

This exercise takes you through many of the available open-string arpeggio triplets. These triplets use an open string to bounce to a higher position on the fingerboard. The strings numbers are indicated below the triplet to help you understand this. For example, the G string is ①, D is ②, A is ③ and E is ④. This may feel a little unusual at first, but you'll soon find the technique to be very useful. The arpeggios listed as major triads can be used on dominant sevenths and major sevenths as well.

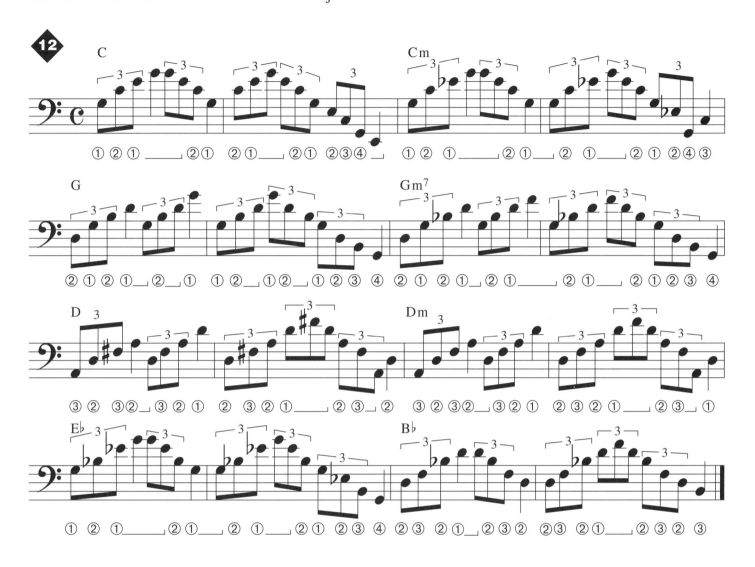

Even More Triplets

Here are some more triplets. The first one is very common; it uses a pull-off onto an open string.

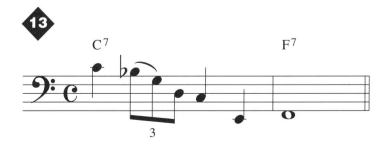

Here is one that lays well on the fingerboard using the open G string.

This one works well here…

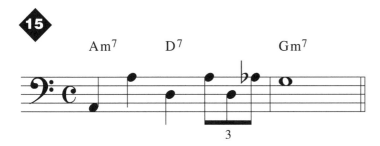

This one slurs into the second beat; notice the indirect resolutional pattern.

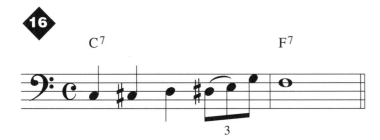

There are limitless possibilities to all the triplets that can be used. Availability is determined by the chord progression, where you are located on the fingerboard, and what will flow naturally. If the triplet doesn't lay well, it probably won't sound smooth.

Here is an example of triplets in action. After you learn this line, work out your own ideas. While you're experimenting, always look for more ways to be creative with a concept.

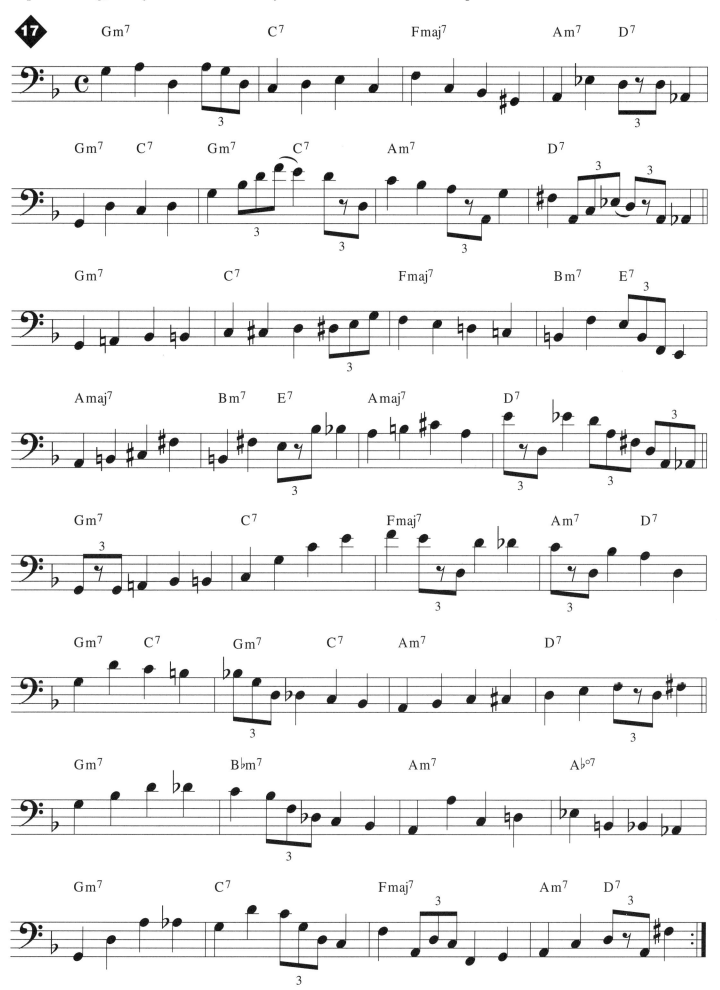

Triplets with Dead Notes

Next we'll look at triplets with dead notes. These are sometimes referred to as "rakes." The amount of "deadness" can vary slightly from one note to the next, making this technique tricky to explain precisely. Sometimes the dead note is muted with the left hand, and sometimes with the right. Sometimes only one note is dead, and other times all three notes are dead. This technique varies quite a bit; listen to the examples closely and go for the sound.

Dead notes will be notated in one of two ways. They will be written on their specific pitch, or on their open string. Open string dead notes will have an "O" written underneath.

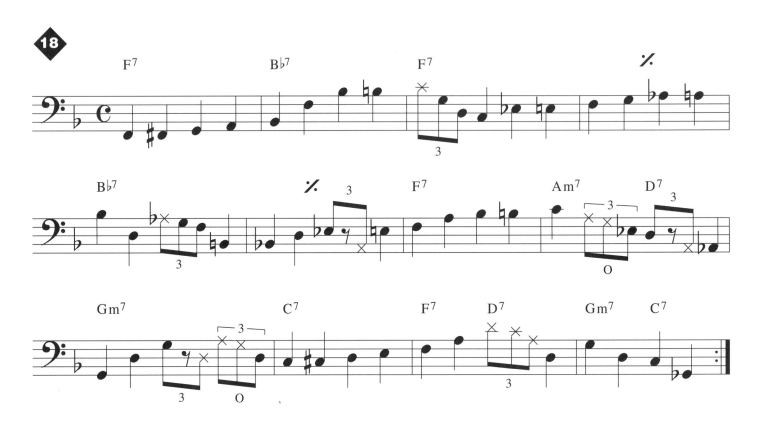

Now it's your turn to put all the different triplets together for yourself. Feel free to use skips as well. Remember that a little goes a long way and use them sparingly. Transcribe the recorded bass line, then learn to play it.

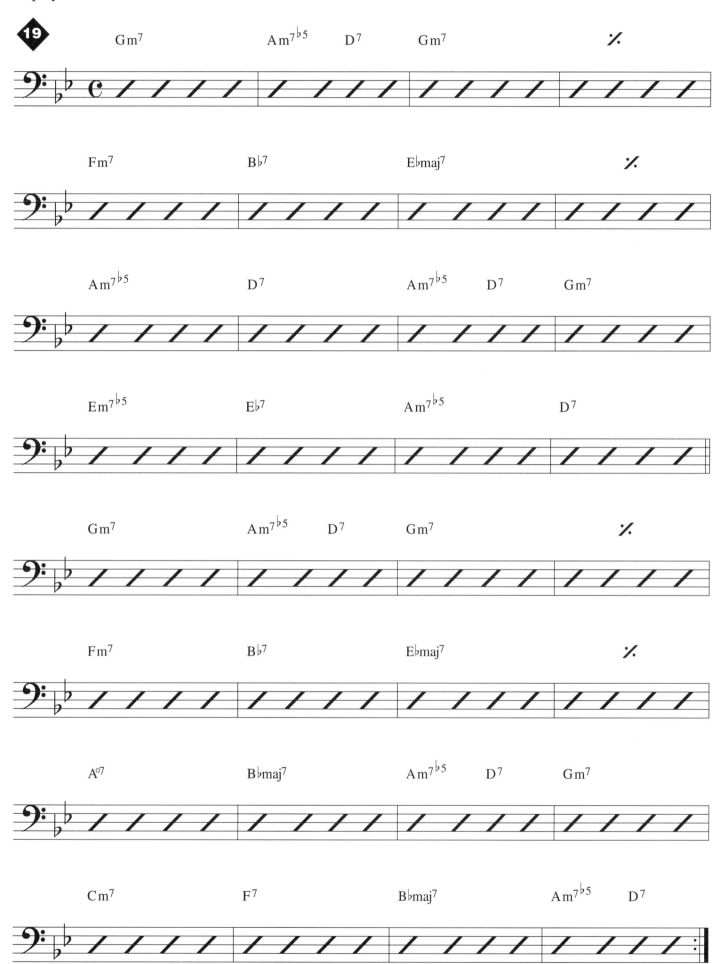

Expanding the "Two" Feel

The "two" feel is an important part of walking bass lines. While playing in two is not actually walking, it is often the way bassists approach a tune while the melody or "head" is being played. The two feel is commonly used when backing up singers, before going into a "four" feel for the solos. Often the two feel is used for the first chorus of a new soloist, giving them a chance to settle in and build up to a peak. The two feel is also used on "society" gigs where standard tunes are played for dancing.

Here is the two feel at its most basic, just half notes, mostly roots and fifths. We must be able to play in this simple manner before we can effectively expand the concept. In fact, sometimes it is best to play this way and leave out the fancy stuff.

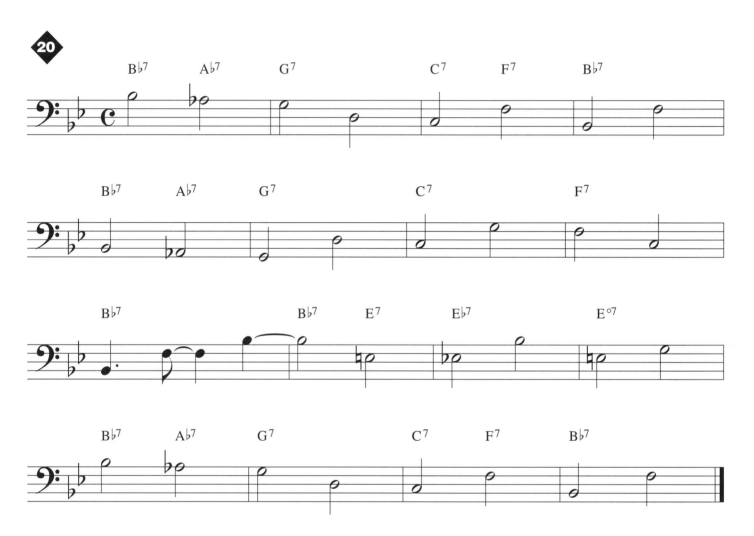

There was a band playing on board the ocean liner Titanic. On that fateful night as the great ship was sinking, the freezing water reaching the level of the bandstand, the bass player looks at the drummer and says, "To hell with it man, let's play in four!"

Here is an example of the expanded two feel. This is more appropriate in a jazz setting than a "straight" two. Even with the freedom of jazz, we still have to anchor the band, so it's important to keep the line balanced. Notice how this example incorporates rhythmic embellishment *and* bars of straight two. Remember, we don't want the two feel to become a bass solo. Notice that there is even a bar of walking thrown in once in a while. It's fine to do that, but we want to save the four feel for the right moment. Coming out of the two feel into four is a great way of creating a tension/release pattern. Use it wisely.

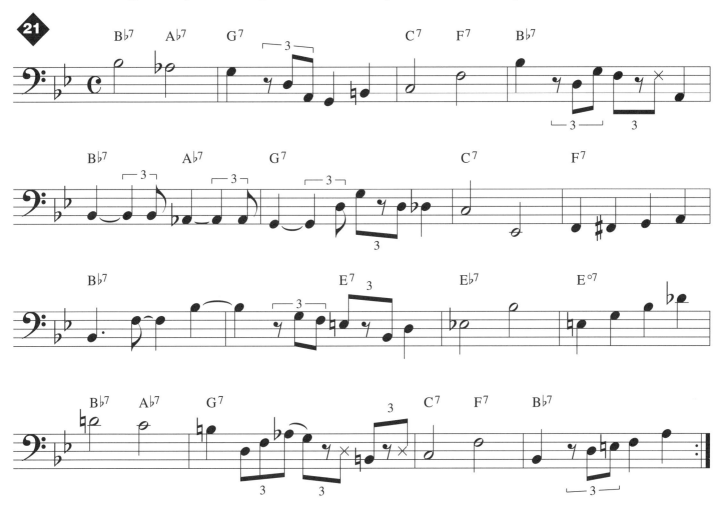

Next you will practice the expanded two feel over a blues progression. Remember to keep the line balanced. Use rhythmic activity with taste, and use plenty of good old half notes!

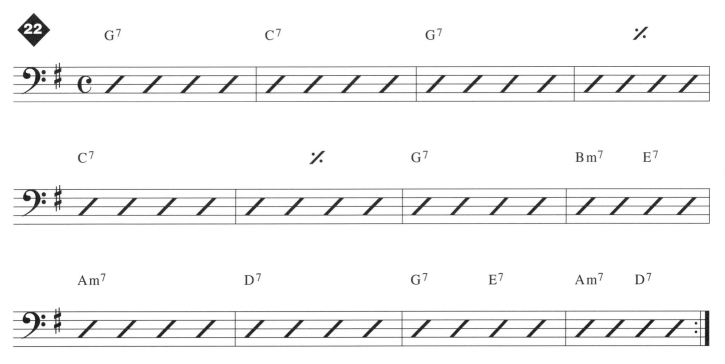

PART TWO

Overview

In the first part of this book we learned how to expand our bass lines by using rhythmic embellishment. In part two we will learn to expand our melodic concept. First, we will look at targeting non-chord tones on the downbeat of new chord changes. Then, we'll learn how to interpret chord symbols with tensions, or "upper structure triads." We will discuss playing on modal tunes and learn a concept I call "modal mapping" to expand your understanding of that style. We'll learn how to use pedal points to open up the groove and harmonic structure. Finally, we'll look at ideas to develop a concept for "walking open." This is what I call "implied harmony," when you play outside of the chord changes, yet still keep an audible reference point to them.

When you combine what you have learned about rhythmic and melodic development, you are well on your way to becoming a knowledgeable bassist. The next step will be putting this knowledge into action in a way that swings.

Targeting Non-chord Tones

In *Building Walking Bass Lines*, we spent a lot of time developing the approach/target concept. We identified our target notes, and preceded them with a type of approach note. Up until now in the present book, our target notes have been strictly chord tones, mostly the root. It should be obvious by now why the root is important to play on the first beat of a new chord change. As we expand into a more sophisticated level of playing, playing the root on beat 1 of a new chord change no longer has to be our ruling principle.

The other chord tones have afforded us a degree of freedom. They get away from the roots yet stay within the material that is immediately present. Now we can learn to use non-chord tones as our target notes. This will free us completely with respect to melodic choices. Once you understand the bigger picture of a chord progression and know various resolutional patterns, you can play anything you want as long as you know how to make it work. There are no mistakes, just missed opportunities! Unfortunately, some people take this sense of freedom to mean that they don't need to know anything in the first place. "Hey, if I can play anything I want, why go through all that stuff? Why not do it right away?" While boldly charging off into the free universe has its merits, you can't expect to function within a set of changes at optimal level without knowing the possibilities. This is like trying to find a friend's house in Los Angeles by heading west on 23rd street in New York, without a map! You may eventually get there, but not easily. Instead, bring a map, and pack a lunch, it's going to be a long trip. But enough of the soapbox routine. Let's get to work.

Using Scale Tones as Targets

Since we have used chord tones already, the next step is using the notes that occur between them. These are the scale tones. If a chord consists of a root (1), a third (3), a fifth (5) and a seventh (7), then our next choices will be scale tones 2, 4 and 6. It is possible to avoid the root altogether, or simply delay it to another beat in the bar.

If we delay resolution to beat two, then this is our line.

If we put off resolution until beat three, then we have more choices. This example targets scale tone 2 and resolves into the root using a double chromatic approach.

This one uses scale tone 2 and resolves by using a dominant approach.

This one uses scale tone 2 and resolves by using a lower chromatic approach.

Putting the root off until beat 4 is possible, but you have to take into account what comes up in the next measure. If a change is coming, there must be a way for the root to work as an approach to the new chord. Given our new realm of possibilities, this shouldn't be a problem.

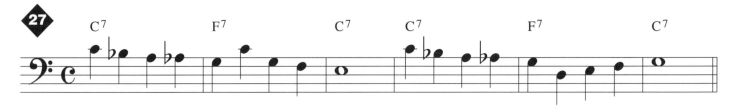

Due to the half step clash with the major third, using scale tone 4 is very tricky on chords with a major triad. Most people will say it's just dead wrong, especially on the downbeat. A dominant chord will withstand the dissonance much better than a major seventh chord, but it is still possible to use scale tone 4. We will explore this if for no other reason than to help you build the confidence to know you can pull it off somehow. Rather than make it wrong, find a way to make it right. This one isn't bad at all.

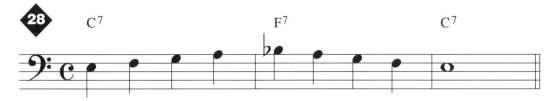

This one works too.

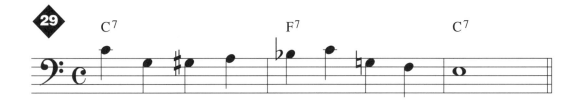

Some other possibilities exist that might require some more "follow-up" work to weave them into the fabric, but we'll get into this later on. On minor chords, it's always acceptable to have scale tone 4 on the downbeat.

Here is an example using scale tone 6.

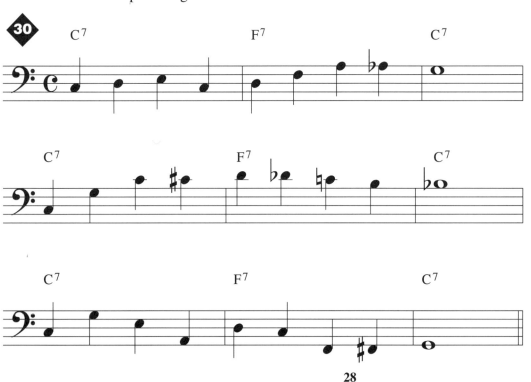

Now we'll put together all the scale targets to create a line with more melodic freedom.

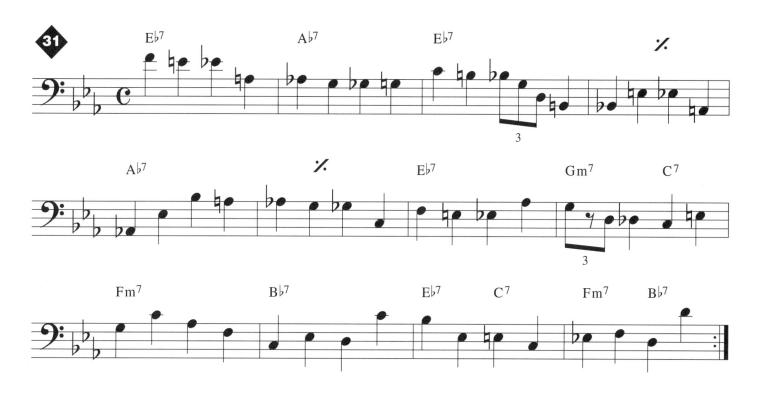

As you can see, this concept opens the door to a whole new set of opportunities. The bass line can become a real melodic force in the music as well as being foundational.

Now it's your turn to use this concept on your own.

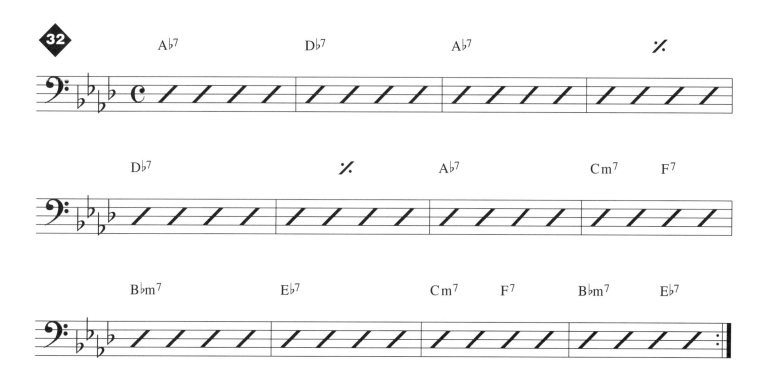

Using Chromatic Passing Tones as Targets

The next thing to add to the bass line is the chromatic passing tones that occur between scale and chord tones. Once this has been understood, you basically have every note available to you at any time. This concept may seem odd, but in reality, once you have the big picture, everything works. Some things may work better than others, but it can all work.

The key to making some of these notes work is an idea I call "weaving." If you have a note that might be questionable (as some of these choices are), you can weave it into the fabric of the line by supporting it with other notes after the fact. There's an old saying in jazz: "If you make a mistake, make it twice, and then it's a motif." I'm not suggesting that you go off and deliberately make mistakes; they'll happen on their own. Just remember: what you may think of as a "mistake" can work in some way. Maybe it won't be brilliant all the time, but a clumsy save is better than dropping the ball.

Many of these chromatic notes sound great if used effectively; others can be just for those important saves. It's always better to hit a "wrong" note and keep moving than to stop and shake your head because you can't believe how stupid your note choice was at that moment. Believe me, I've seen it happen more than once. In actuality, some of these notes are not "chosen," they just happen. An important thing to realize is at some point your bass line is no longer an act of conscious decision making. It becomes a living, breathing entity of its own. You look at the changes, or maybe you hear them, and you play. The line comes through you, out of your bass, into the air where it mixes with the other instruments, back into your ears, and so on.

Here are some chromatic targets that work easily. This one targets ♯4 and uses an indirect resolution to the 5.

This one targets ♭9 and uses the indirect resolution to the root.

This one needs a little more weaving after the fact, but still works.

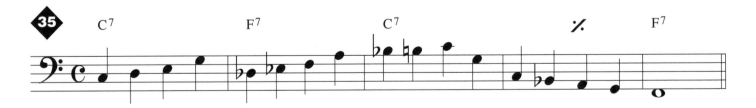

We are definitely stretching it, but that's the point. Here's a longer example of this concept in action.

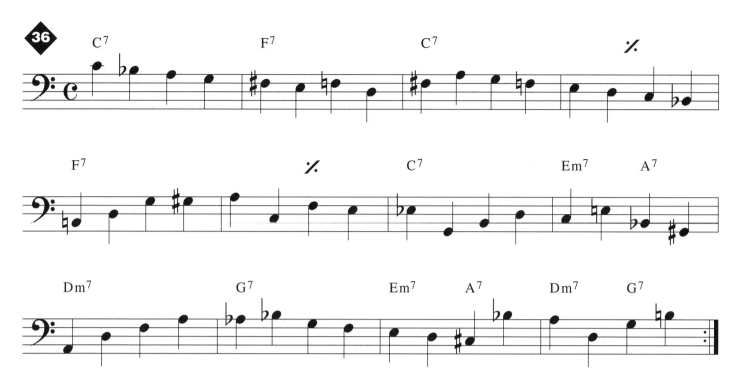

Okay, it's your turn to make it or break it. Focus your ears on where the line wants to go. Now that you have seen how everything works, relax and let the line happen.

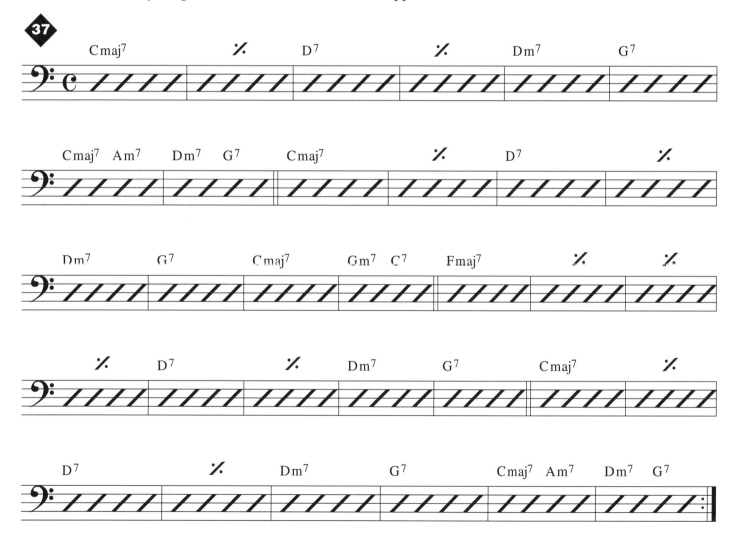

Interpreting Chord Symbols with Tensions

By now I'm sure you've seen chord symbols with extra numbers attached: C⁷,⁹,¹³, A♭maj7♯11, G⁷,♭⁹,♭¹³, etc. Perhaps you've been wondering how the numbers affect you as a bassist. These numbers are called tensions, and they reflect upper structures that are built on top of the basic chord form. Tensions are actually the scale tones that occur in between chord tones, except that they are up an octave.

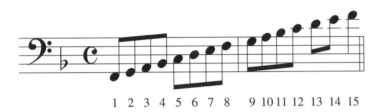

When you build up a chord structure in thirds from the root you have 1, 3, 5 and 7. Continuing up in thirds, you add 9, 11 and 13. Tones 10, 12, 14 and 15 are not called tensions because they are actually chord tones up an octave. These are the "natural" tensions.

When you flat or raise a tension by a half step it becomes an "altered" tension. All that happens is that the scale tone is raised or lowered. If you see a "♭9" added to a chord symbol, then you would play a flat 2 in your scale line as you walk through that chord.

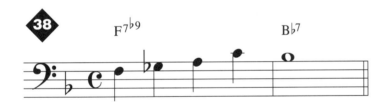

A "♯9" gets a sharp 2 in the scale (also known as a flat 3), "♯11" is a sharp 4, and "♭13" is a flat 6. That's all there is to it. When you see tensions in a chord symbol, make the appropriate adjustments to the scale tones as you walk through the chord.

Playing Over Modal Tunes

Modal tunes are characterized by long stretches of one chord that use a particular scale as the basis of improvisation. For a bassist, looking at 16 bars of Dm7 can be a challenge. "What do I do with all that space?" you may ask, or "What else can I do besides pound out D Dorian all day?" Both are valid questions which will be answered shortly. Before going any further, we should review the modes and their corresponding chord structures.

These are the modes and their diatonic chord structure in the key of C.

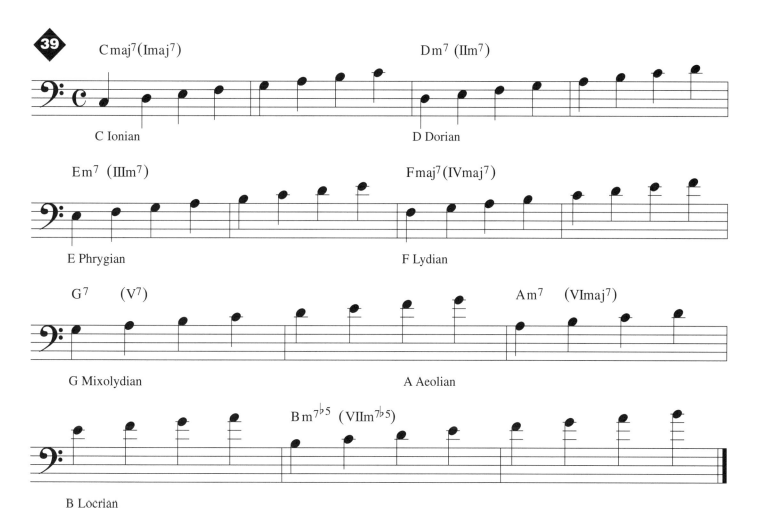

Each chord has its corresponding mode, for example, if a song has four bars of G7, then the scale for those four bars would be G Mixolydian.

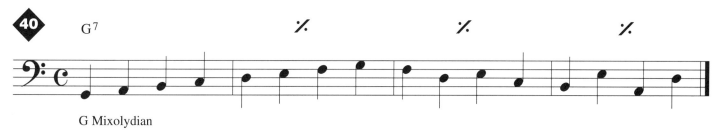

This is what we use when we look at it from the root level. However, there is much more available.

Now that you have reviewed the modes, we'll discuss a concept I call "Modal Mapping." Essentially, this is the process of examining a progression, determining the key center of the moment, choosing other modes from that key center and stringing them together in a semi-logical fashion to create a modal map of the tune.

In the aforementioned example, those four bars of G⁷ used the Mixolydian mode. This occurs within the key of C. With the modal mapping concept, we can see that all the other modes from the key of C are available for use as well. In this particular case, the C Ionian is best avoided. Due to the nature of the movement, starting and ending a line on the fourth scale degree from the root of a chord containing a major triad would be hard to justify.

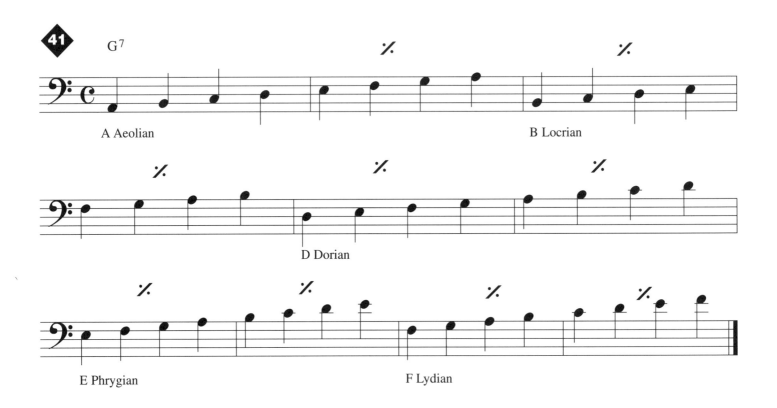

Now that we have this idea going, let's put it to use on a real tune. The next example uses the chord changes of a very popular modal tune made famous by Miles Davis. The chords are sixteen bars of Dm⁷, eight bars of E♭m⁷, and another eight bars of Dm⁷. Not much going on is there? On the surface, this progression is deceptively simple, but as you dig into it, you'll find there are many layers to this tune. The prevailing mode for each chord is Dorian. This means they are both IIm⁷ chords from their respective keys. Dm⁷ is from C major, and E♭m⁷ is from D♭ major. We will use the rest of the modes from these keys to create our modal map. Since we are playing quarter notes, we have two bars to complete a scale, so every two bars we will shift to a new mode from the same key. General rules for resolving from one scale to the next will follow the basic approach types — ascending and descending chromatic, scalewise and dominant.

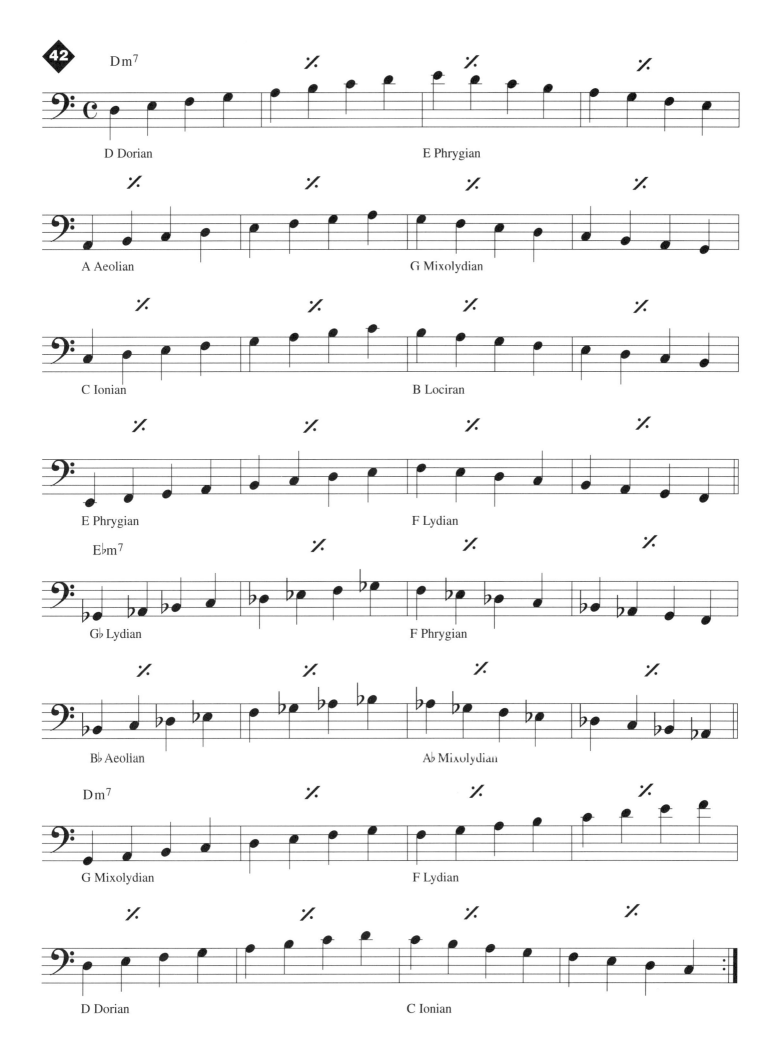

This technique is being illustrated this way to show you many possibilities in one chorus. In actual usage, you will probably want to stay in one modal center for a longer duration. Each mode and each chord type has its own color. Different combinations of chords and modes will create unique textures. Explore them all and learn how they feel. Modal mapping can also be used effectively on tunes that have standard chord progressions. When we look at a tune, we need to see the key centers that are present. Some songs may stay in one key center, others may change key every other measure.

Here is a standard progression with an explanation of how modal mapping works with it.

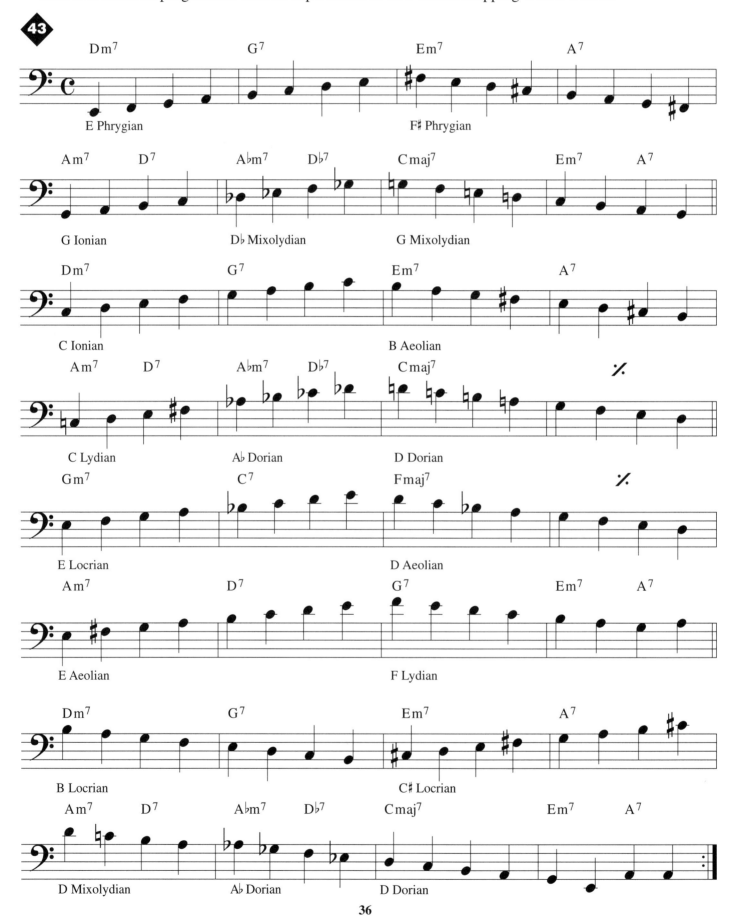

The previous tune has an AABA form. The first two measures of the A section is IIm⁷ to V⁷ in the key of C major. Measures 3 and 4 are IIm⁷ to V⁷ in D major. Measure 5 is IIm⁷ to V⁷ in G major. Measure 6 is IIm⁷ to V⁷ in G♭ major. Measures 7 and 8 are in C major, except for the A⁷ chord on beat three of measure 8. For this, we need to adjust our scale and use a C♯ to match the chord structure. Because measures 5 and 6 each are in a different key, we can't play an entire scale all the way through. So, we must shift to a new scale halfway through. This works very well because we can keep the momentum of the line going while staying within the tonal centers that occur.

The first four measures of the B section is IIm⁷ to V⁷ to Imaj⁷ in the key of F. The next two measures are IIm⁷ to V⁷ to Imaj⁷ in G major. The seventh measure of the B section goes back to the key of C with a G⁷ chord. The last measure of the B section is a turnaround to the Dm⁷ at the top of the next A section.

As you can see, this concept really opens up a typical II–V progression and gives it a feeling of spaciousness.

Create Your Own Modal Map

Here is a chance to do your own modal map. This thirty-two measure progression modulates frequently. The key centers are expressed with very typical chord movement. Once you have determined the key centers, choose modes from that key, preferably not ones based off the root of the chord. Whenever possible, use the entire scale. Resolve your scales into each other smoothly. Do more than one version; there are limitless possibilities.

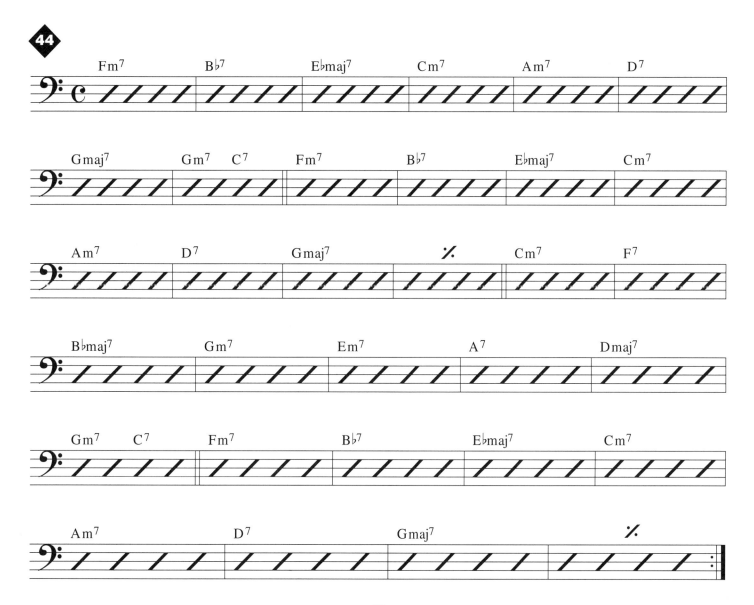

Pedal Points

A pedal point occurs when the bassist stops walking and hangs or "pedals" on a particular note. The most common note choice is the dominant pedal. On any given chord, we can pedal on its fifth and create a feeling of suspension. This is often used as an intro to a tune. For example, the dominant of the key is used as a pedal on beats 2 & 4 while the chords change over the top of the pedal.

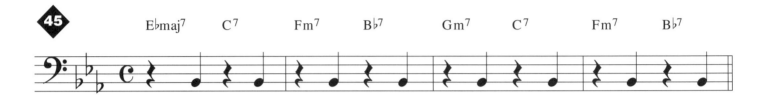

Pedal points can be used much like modal mapping to create textures that stray from the root motion. For example, on Dm7 you can pedal on any of the notes from the key of C major. Instead of playing up and down the mode built from a scale degree, laying on the pedal point creates a feeling of harmonic and rhythmic suspension. This concept lets you feel the differences each modal center can create. The next example is the same progression from example 42. This time, we will pedal different tones from the key centers. Pay attention to the rhythmic ideas as well. Pedaling is another way to open up the tune.

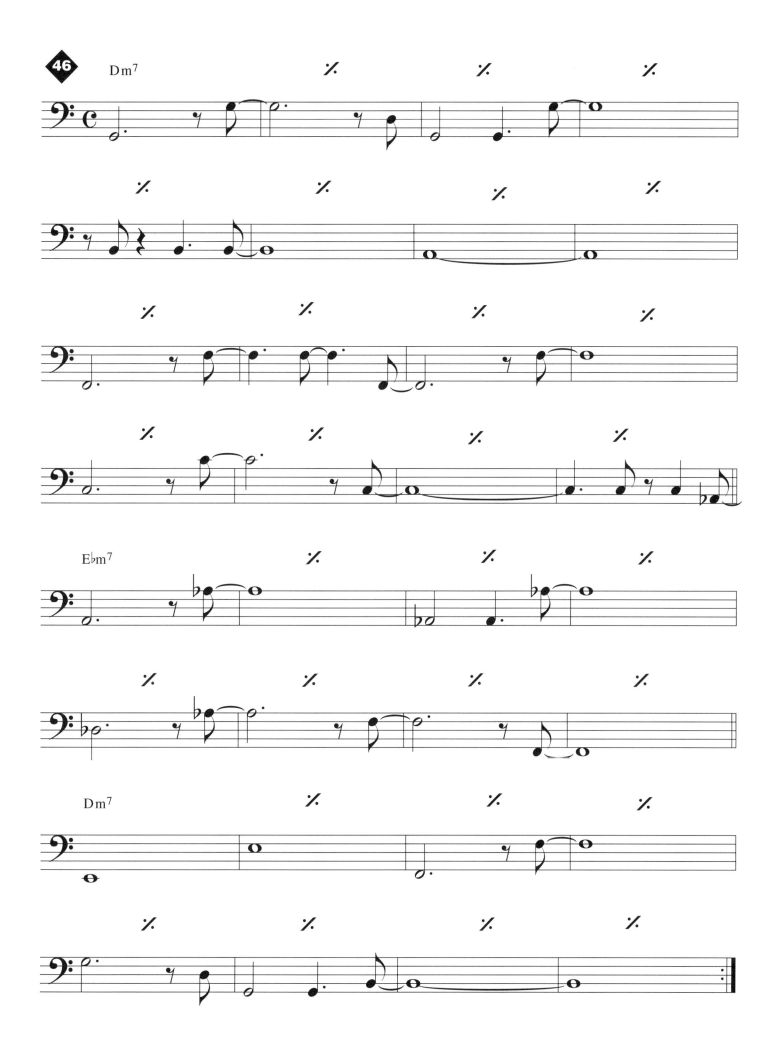

A Listening Assignment

Find the original recording of "So What" on Miles Davis' album *Kind of Blue*. Listen to how Paul Chambers (one of the greatest bassists who ever lived) approaches the tune. Grounded in the straight ahead school of playing, he plays beautiful swinging lines, but tends to emphasize the root of the chords. Now find a recording of John Coltrane's "Impressions." This song has the same chord progression as "So What," but as it is played by Jimmy Garrison (another one of the greatest bassists of all time), it takes on a completely different sound. In the years between these recordings, modal jazz developed a freer flowing sense of time and harmony, which was due in part, to the use of pedal points in the bass.

Walking Open: The Art of Implied Harmony

It is quite possible to walk over a tune without being restricted to any obvious reference to the harmony and still represent the tune. Ron Carter is one of the masters of this approach. To accomplish this, we must draw upon an unshakable knowledge of the harmonic structure of a tune. If you're going to mess with it, you better know what you're messin' with! In addition, you must have a firm grasp of what is possible — basically, everything. Another important awareness needed for the successful use of this approach is intimate familiarity with the melody of the song. This is something we have not gone into, in part due to copyright restrictions on the use of other people's melodies. However, knowing the melody creates another grounding point for you as you boldly go where no bassist has gone before. Working bits of the melodic structure into your walking lines is a good way to refer to the tune you are playing without being a slave to harmonic conventions. On top of all this, we add one more factor — attitude. Much can be accomplished with the proper attitude. Sometimes playing bass in a jazz context can be like playing poker — you can win big even if you don't have the best hand. Regardless of your level of confidence in your ability, you must project authority. This is not to suggest that you become a dictator (particularly if you're "bluffing"), but a call to all bassists to *mean what they play and play what they mean.*

In any case, this is a topic I will teach by demonstration alone. To pull this off takes much experience with chord changes and melody. There is no real "method" for this technique, just an idea about how we can "take it out" but still be "inside."

This example is a standard tune that has been "taken out." I will play a line that is fairly oblique in its reference to the harmony, takes a few pot shots at the melody, and uses many questionable choices in the process. And, it works. Remember, this approach is not recommended for someone filling in as a substitute player with the local "society" swing band!

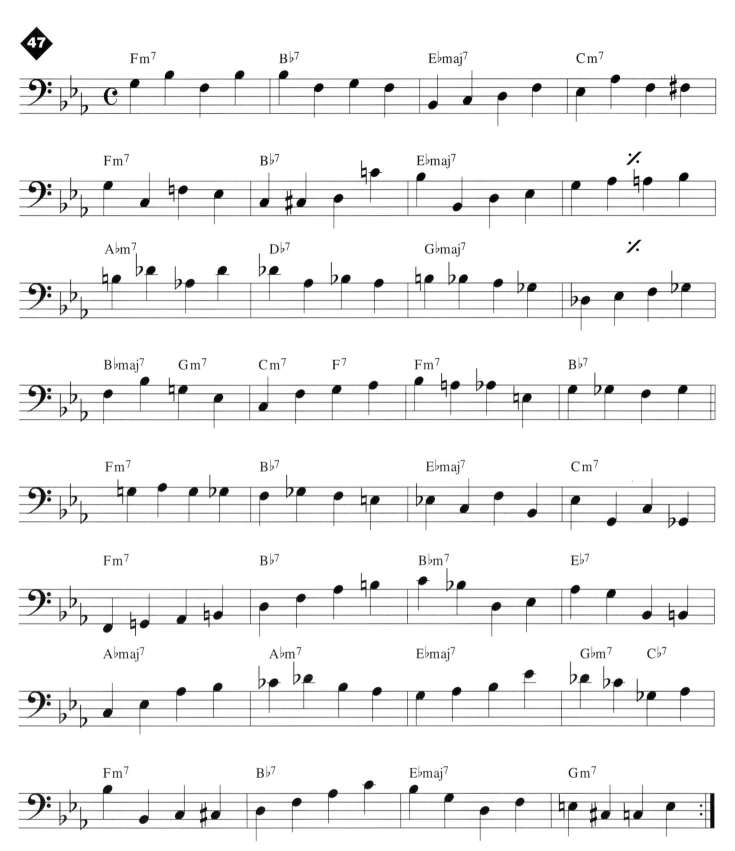

As you can hear, this bass line pushes the limits of what is acceptable, yet, at the same time, has an unmistakable sense of the tune. An experienced listener will recognize this tune because of the thinly-veiled references to the melody. To avoid the complications of copyright infringement, I am unable to name the specific tune. You could ask your local jazz guru to tell you. Go to this person and say, "I need help figuring out the name of this tune. I've asked every one in town and they couldn't tell me. So it's you or no one." In any case, this concept takes the bass line into the realm of melodic accompaniment. We are backing up the tune, but also creating a strong melodic statement of our own. Work with this idea as you move ahead with your walking lines. After you have played through this a few times, create your own "out" line. Take a tune that you are familiar with and walk while outlining the melody.

A Closing Word

The material presented in this book will provide you with food for thought for quite some time. Even if you have moved through everything to your satisfaction, there is always another level to which you can take your understanding. As you take these concepts and apply them in the real world, you will discover more things about them. There is no end to the knowledge that is available to you. It is up to you to take on the responsibility to continue to learn. Playing a walking bass line is an act of creation. We are bringing the tune to life, constantly pumping fresh ideas into it. We are the heart of the band.

Beyond the actual notes we choose to play, there are the many layers of time. Getting in the groove is ultimately what we are here to do. Take it upon yourself to study the great rhythm sections in jazz. Listen to Walter Page and Papa Jo Jones, Paul Chambers and Jimmy Cobb, Paul Chambers and Philly Joe Jones, Paul Chambers and any drummer, Jimmy Garrison and Elvin Jones, Charles Mingus and Danny Richmond, Ron Carter and Tony Williams, Scott LaFaro and Paul Motian, Sam Jones and Billy Higgins, Dave Holland and Barry Altschul, Eddie Gomez and Jack DeJohnette, Jaco Pastorious and Peter Erskine, Marcus Miller and Omar Hakim, John Pattitucci and Dave Weckl. Each of these great pairs has its own distinctive groove. A groove that is created by the blending of two people. As you develop, remember that the spirit of cooperation is just as important as having your own thing together. If any of the above mentioned duos refused to cooperate with each other, no music would have ever been made. And, no one would have ever hired them. Based on how many recordings these rhythm sections are on, it's obvious that they understood the need to cooperate. We will not impress anyone by going into a band situation with the idea that we know everything there is to know, by refusing to listen to the other musicians, or by forsaking our primary function. As bassists, we have a huge responsibility to the band. We are relied upon to be the glue that keeps it all together; harmony, melody and rhythm. Take this responsibility seriously, it is our life.

Appendix

Using the Appendix

This section is provided to give you more opportunities to put your new skills into action. You can use this section at any point in the book; don't feel you have to finish everything before you work through these tunes. At each step of your learning process you will have new ideas to bring to each progression. Each progression has a recorded bass line that is not written. It is strongly suggested that you transcribe these lines; the process will be of great value to you.

The last three examples are the "mystery" tunes promised earlier. Instead of a written chord progression being provided, helpful suggestions will be given. Then, you're on your own. As mentioned, the ability to play tunes by ear, without prior knowledge, is extremely important, but is becoming exceedingly hard to find in a bassist.

Due to the proliferation of instructional materials and "fake" books, students of jazz have become more and more dependent on visual information in order to perform. While this mode of learning is very important, in its truest form, jazz, and music in general, is an aural phenomenon. Consequently, the most direct route to the source of this experience is your ears. And so, you will have to use them. While it may seem as if you are being asked to perform an impossible task, trust me, it happens every day. At some point or another, you will be asked to play a tune that you don't know (it probably has happened already). You have a few choices: say "no" (which will not endear you to the band leader), say "yes" and do it poorly (which will also not endear you to the band leader), or say "yes" and do it well (with the predictable result). In reality, you may not have a choice in the matter. On the bandstand, the horn players confer with each other, ask the piano player if he knows the tune, and start counting, 1...2...1, 2, 3, B♭, and you're off. Suddenly you are thrust into a tune that you don't know. You can panic, or you can calmly keep your ears open wide and learn it. The time you spend with the three mystery tunes will help you do this.

Each page has a list: Things to Consider, Things You Should Know and Things You Should Do. These lists are appropriate for all three tunes. Read through them all before attempting the first tune.

This tune has an ABAC form.

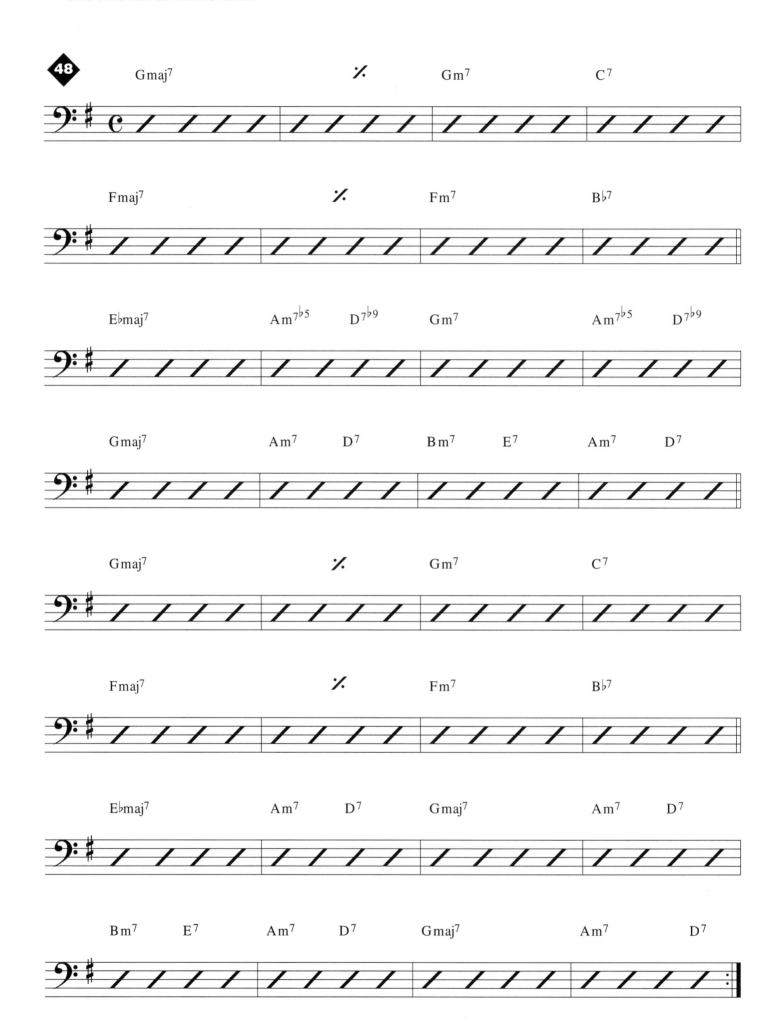

This bop tune has a "Rhythm Changes" A section in F major and a chromatic II-V bridge. Look for different ways to approach the bridge. Use modal mapping to smooth your way through, use root/approach note, or find a melodic fragment to develop.

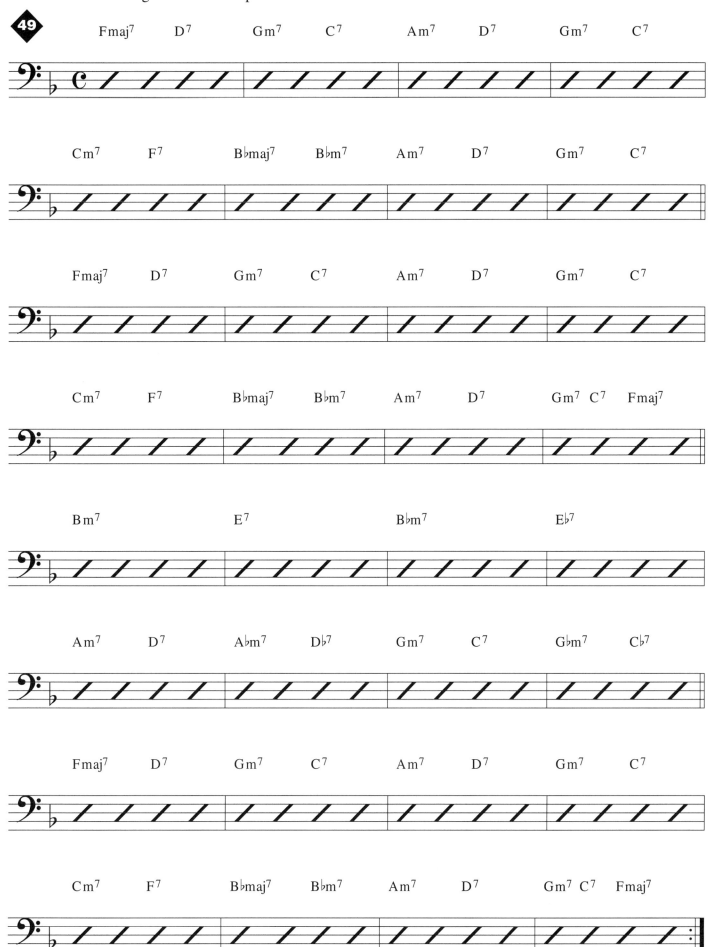

This tune has several key centers in the A section.

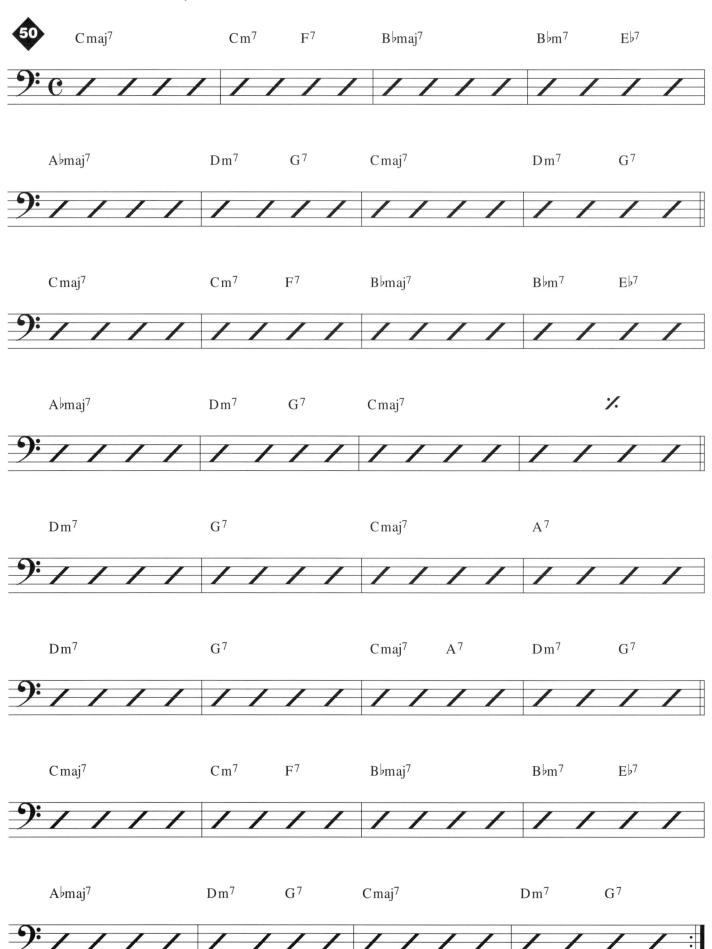

On this tune, use the "expanded two feel" style. This tune was popularized by the Bill Evans trio.

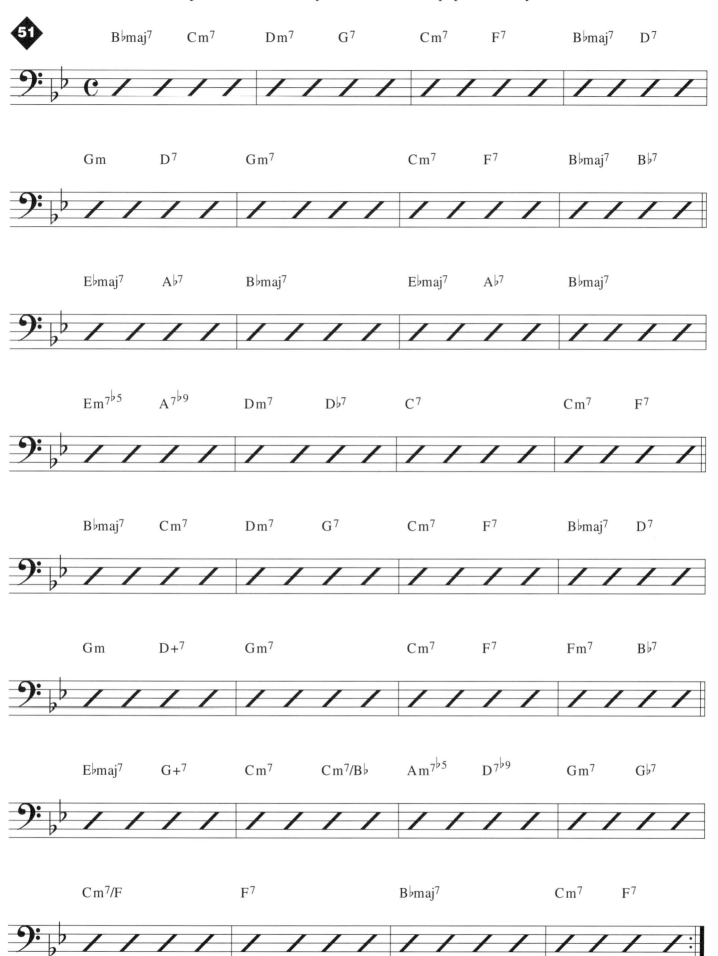

This modal tune has a tricky form. Sixteen measures of Gm⁷ (Dorian), sixteen measures of Am⁷ (Dorian) and eight measures of Gm⁷ (Dorian). Pay attention to the last eight measures of Gm⁷, it's easy to forget where you are and get to the bridge too soon.

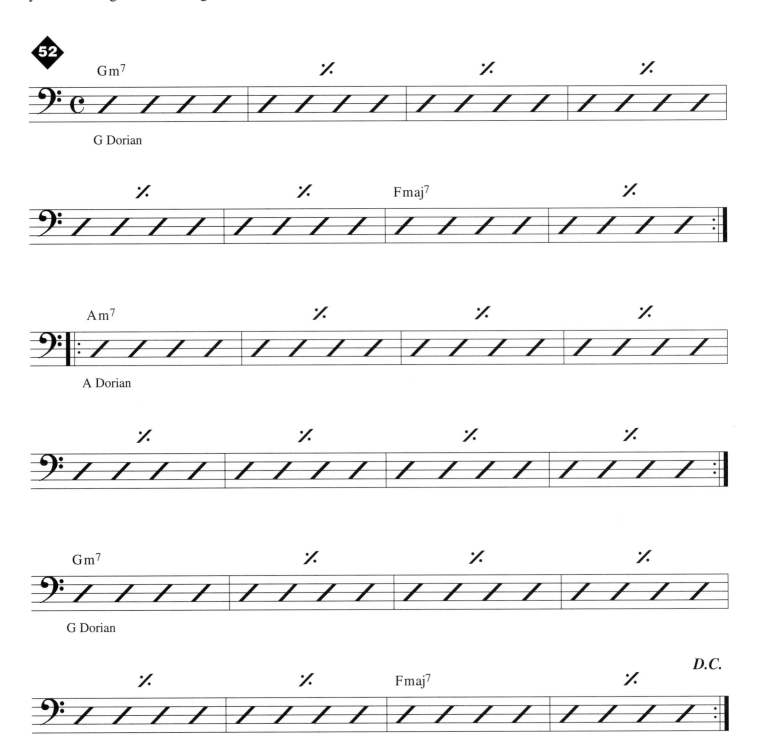

Have you met the challenge of the bridge on this one? It has some tricky modulations.

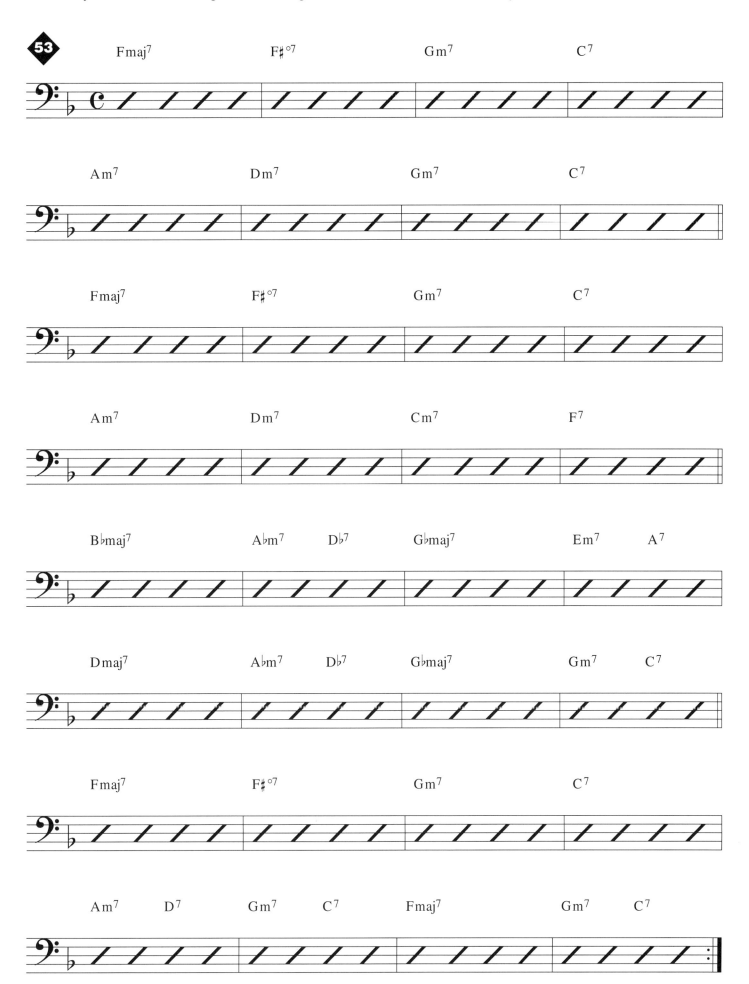

This tune has a very repetitive A section in C minor. It provides a good opportunity to use pedal points to create some interesting textures. The bridge goes to the relative major key of E♭. Be careful to keep track of the form; it's very easy to blow right through the bridge without noticing. Pay attention to the E diminished and F♯ diminished chords.

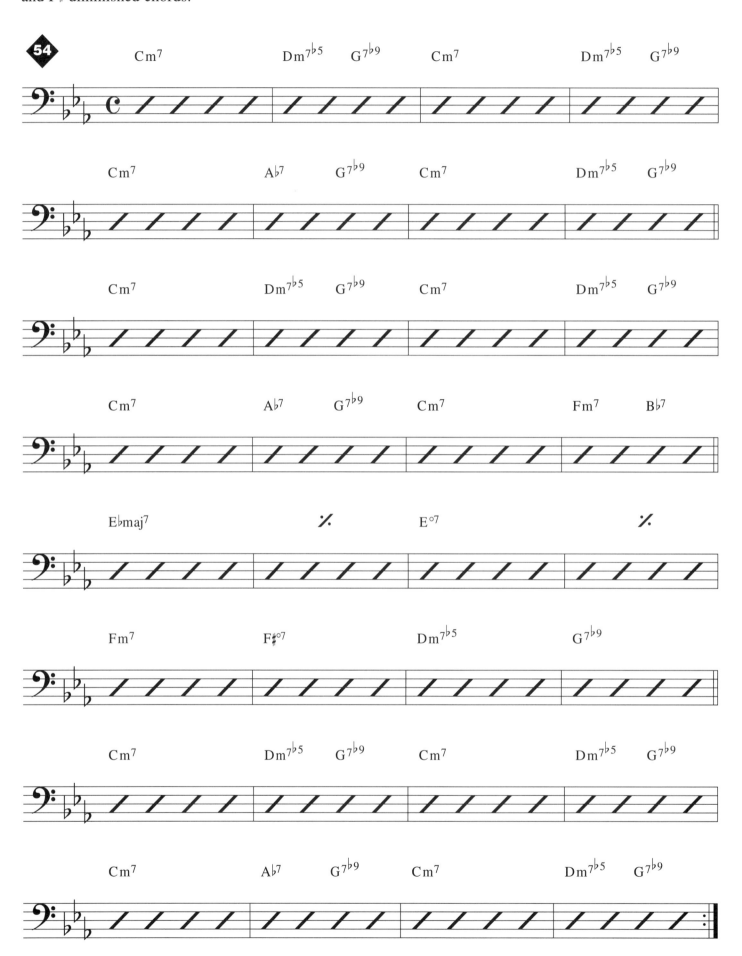

The Three Mystery Tunes

 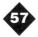

Things to Consider

When put in the position to "fake" a tune, there are a few things you need to consider. Some of them are:
- What key is this tune in?
- Is it in 4/4, 3/4, or god forbid, 5/4?
- Should I walk? Should I play in 2? Should I pedal?
- Does this sound familiar?
- What does this remind me of?
- What is the form? AABA, ABAC, AAB, AB or ABC? Is it a blues? Is it "Rhythm Changes" or similar?
- Does the song have any key changes built in?
- Does it stay in one key?
- What's the first chord of the bridge? (that is, the B section)
- Does the feel change, or stay the same throughout? (Some tunes may go to a Latin feel in the bridge, or may start Latin and go to swing in the bridge.)
- Are there any repetitive chord patterns?
- Is there a break at the end of the head? (Often there is a break before the last turn around so the first soloist can lead into the the top of the form.)
- If there is a break, will it happen at the end of each chorus or just for each new soloist?
- Is the solo form the same as the head?
- If I solo, will it go back to the head afterwards, or will it go to a drum solo, to trading fours with the drums, or trading fours with the horns?
- Is the head the same on the way out as it was on the way in? (Usually it is.)
- Is there a tag at the end of the tune? (A tag is a repeated section, usually two or four measuress long, repeated two or three times.)
- Is there a special ending?
- Was that the end?
- Do I get the gig?

Things You Should Know

Some of these situations do not always occur, but they happen enough to warrant mention. It is not advisable to be rigid in your assumptions about a tune; it could be the one tune that fits none of your expectations. Even after you have figured out a tune, you can be surprised. Here is a partial list of things you should be aware of:

- A tune, particularly a standard, will follow a common form, AABA being the most common. Most tunes are thirty-two measures long. Many Cole Porter tunes are sixty four measures long.
- An A section is usually eight measures, if it repeats, the last measure (measure 8) will most likely set up the top of the next A section with a turnaround measures.
- A turnaround is usually a II-V movement that sets up the next section. Sometimes the turnaround is I-VI-II-V, or III-VI-II-V (which is virtually the same thing).
- The A section may start on the I chord, or maybe with II-V-I. It may start on the IV chord (as in "Just Friends"). Remember, the first chord you hear may not be the key of the tune, but it could be.
- The second A section is usually the same as the first, but the last one or two measures may be different. If the first A set up the second A with a turnaround, then often the second A will come to a harmonic rest point and go to the tonic chord. Either that will happen, or the second A will set up the bridge with a turnaround, or perhaps it will do both.
- The bridge is usually 8 measures, though sometimes 4, or 16.
- The bridge is usually set up with a turnaround at the last 1 or 2 measures of the second A, but not always.
- The bridge may go to the IV chord, or the II chord, or III7 (as in the "Rhythm Changes" bridge). The bridge may modulate to an entirely new key.
- The bridge will often set up the next section with a turnaround.
- After the bridge, the tune usually goes back to the A section, but not always.
- The last A is usually like the second A, coming to a harmonic resting point at the tonic chord in measure 31 of a thirty-two measure tune.
- Measure 32 can be a turnaround back to the top, even if it's not written that way.

This is a lot to digest, but this is what goes on in a tune. The best approach is to read the lists, get the ideas in your head, then open your ears and listen big!

Things You Can Do

There are many things you can do to help yourself deal with the challenge of learning tunes on the fly. Some of these things are preparatory, other things are to be done at the time of need. Here are some things you can do to prepare yourself:

- Study harmony and become familiar with the way harmony functions.
- Study ear training and learn to hear all the chromatic intervals within an octave, ascending and descending.
- Study chords and learn to identify maj^7, dom^7, m^7, $m^{7\flat 5}$, sus^7, dim^7, $+^7$, $+maj^7$ chords by ear.

- Practice melody/harmony relationship drills. Go to a piano and play each of the above-mentioned chord types one at a time. While the chord is ringing, play the root on the bass, then play every chromatic note between the root and octave. Do this slowly and allow yourself to hear what each note sounds like under each type of chord. Pay particular attention to the thirds, fifths, and sevenths in the bass.
- Develop your sense of pitch. Find a tune that you can always recall. Find out what key this tune is in. Practice hearing the beginning of the tune in your head. Remind yourself what key that song is in. Now practice transposing that song to another key. Then go back to the original key.
- Buy a pitch pipe or tuning fork and carry it with you all the time. At different times during the day listen to it. Think of a note and sing it out loud, or to yourself. Check your note with the pitch pipe for accuracy.
- Learn to hear the keys of F, B♭, C, G, E♭ and A♭; they are the most commonly used keys in jazz.
- Practice singing along with your bass lines.
- Sing a note, then find it on the bass. Have someone else play a note, then find it on the bass.

Here are some things you can do "in the moment":
- Relax. You'll hear better when you are calm.
- Pay attention to everything.
- Connect with your bass.
- Listen to everyone very closely.
- If necessary, watch the piano player's left hand. Older-style players (or anyone who wants to be helpful) will play the root on the bottom of their voicings. If it's not the root, it's probably a third or a seventh.
- Watch the drummer. If you are lost in the form, it's good to know that drummers tend to set up the beginning of a new phrase with some type of fill: small fills for A sections, larger fills for the bridge, and usually something very noticeable for the top of the form.
- Retain what you gain. If you figure out the A section, remember it! You'll have to play it again.
- Say a little prayer to your favorite deity before the first bridge.
- When you get through the bridge, be prepared to play the A section again!
- Remember what you learned about the bridge for the next chorus.
- Keep your eyes on the band leader. He may signal a break in the tune.
- Listen to what you're playing. If it sounds wrong, don't do it. If it sounds right, do it again in the next chorus.
- If there's a spot that is giving you trouble, remember where it happens. Each time it comes up, try something else until you find the solution.
- Make sure you can recognize when you've got it. You don't want to keep searching if you already have it.
- Construct a chord chart in your head.
- When the song is over, make sure you ask somebody to tell you the name of the tune. You may have to play it again someday.

Notation Legend

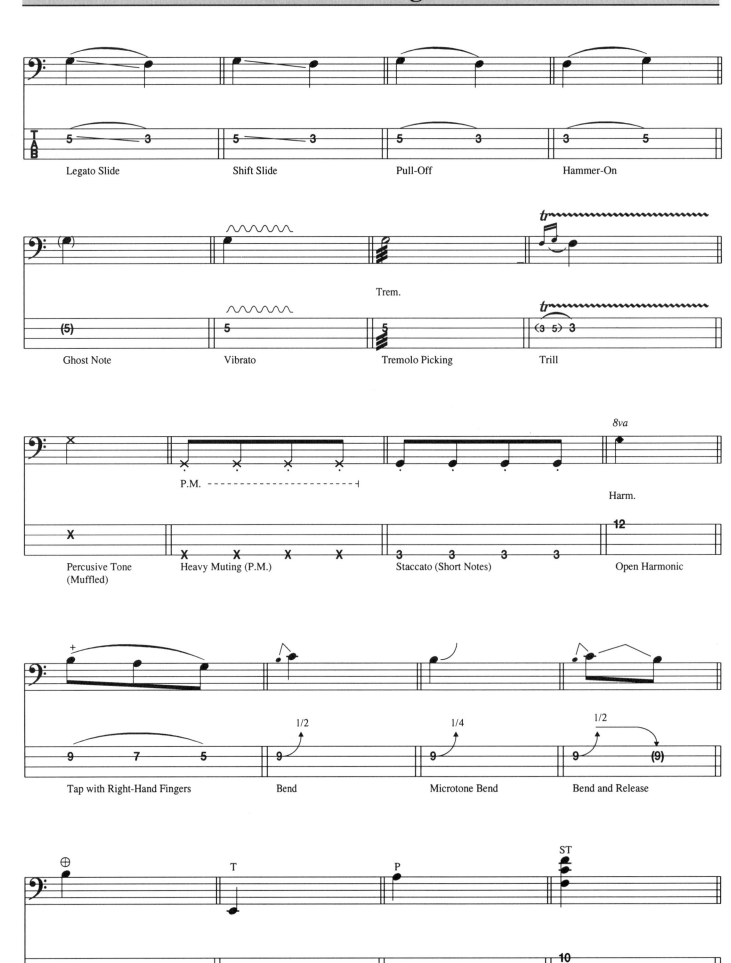

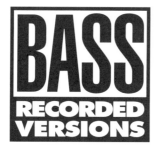

Recorded Versions for Bass Guitar are straight off-the-record transcriptions done expressly for bass guitar. This series features the best in bass licks from the classics to contemporary superstars. Also available are Recorded Versions for Guitar, Easy Recorded Versions and Drum Recorded Versions. Every book includes notes and tab.

Aerosmith – Pump
00660135 / $14.95

Beatles Bass Book
00660103 / $14.95

Best Bass Rock Hits
00694803 / $12.95

Black Sabbath – We Sold Our Soul For Rock 'N' Roll
00660116 / $14.95

The Best Of Eric Clapton
00660187 / $14.95

Stuart Hamm Bass Book
00694823 / $19.95

Heavy Metal Bass Licks
00692878 / $14.95

The Buddy Holly Bass Book
00660132 / $12.95

Best Of Kiss
00690080 / $19.95

Lynyrd Skynyrd Bass Book
00660121 / $14.95

Michael Manring – Thonk
00694924 / $19.95

Pearl Jam – Ten
00694882 / $14.95

Pink Floyd – Dark Side Of The Moon
00660172 / $14.95

Pink Floyd – Early Classics
00660119 / $14.95

The Best Of The Police
00660207 / $14.95

Red Hot Chili Peppers – Blood Sugar Sex Magik
00690064 / $17.95

Red Hot Chili Peppers – One Hot Minute
00690091 / $18.95

Rockabilly Bass Book
00660085 / $14.95

Best Of U2
00694783 / $18.95

Stevie Ray Vaughan – In Step
00694777 / $14.95

Stevie Ray Vaughan – Lightnin' Blues 1983-1987
00694778 / $19.95

For More Information, See Your Local Music Dealer, Or Write To:

HAL•LEONARD CORPORATION
7777 W. Bluemound Rd. P.O. Box 13819 Milwaukee, WI 53213

Prices, contents & availability subject to change without notice.

Vaughan Brothers – Family Style
00694779 / $16.95

BASS BUILDERS SERIES

A series of technique book/audio packages created for the purposeful building and development of your chops. Each volume is written by an expert in that particular technique. And with the inclusion of audio – either CD or cassette – the added dimension of hearing exactly how to play particular grooves and techniques makes this truly like a private lesson. Books include notes and tab.

Bass Fitness – An Exercising Handbook
by Josquin des Pres

The purpose of this book is to provide the aspiring bass player with a wide variety of finger exercises for developing the techniques necessary to succeed in today's music scene. It can also play an important role in a bass player's daily practicing program. The 200 exercises are designed to help increase your speed, improve your dexterity, develop accuracy and promote finger independence. Recommended by world-acclaimed bass players, music schools and music magazines, this is the ultimate bass handbook.

00660177 Book Only$7.95

Funk Bass
by Jon Liebman

Critically acclaimed as the best single source for the techniques used to play funk and slap-style bass! Includes a foreword by John Patitucci and is endorsed by Rich Appleman of the Berklee College Of Music, Will Lee, Mark Egan, Stuart Hamm and many others! Features several photos and a special section on equipment and effects. A book for everyone – from beginners to advanced players! Includes a 58-minute audio accompaniment.

00699347 Book/Cassette Pack$14.95
00699348 Book/CD Pack$17.95

Funk/Fusion Bass
by Jon Liebman

This follow-up to *Funk Bass* studies the techniques and grooves of today's top funk/fusion bass players. It includes sections on mastering the two-finger technique, string crossing, style elements, establishing a groove, building a funk/fusion soloing vocabulary, and a CD with over 90 tracks to jam along with. Features a foreword written by Earth, Wind And Fire bassist Verdine White.

00696553 Book/CD Pack$17.95

Prices, contents, and availability subject to change without notice.

FOR MORE INFORMATION, SEE YOUR LOCAL MUSIC DEALER, OR WRITE TO:

7777 W. BLUEMOUND RD. P.O. BOX 13819 MILWAUKEE, WI 53213

Building Walking Bass Lines
by Ed Friedland

A walking bass line is the most common approach to jazz bass playing, but it is also used in rock music, blues, rockabilly, R&B, gospel, latin, country and many other types of music. The term "walking" is used to describe the moving feeling that quarter notes create in the bass part. The specific goal of this book is to familiarize players with the techniques used to build walking bass lines and to make them aware of how the process works. Through the use of 90-minutes' worth of recorded rhythm tracks, players will have the opportunity to put the new learning directly into action. This book literally gives bassists the tools they need to build their own walking bass lines.

00696503 Book/Cassette Pack$12.95
00695008 Book/CD Pack$17.95

Expanding Walking Bass Lines
by Ed Friedland

A follow-up to *Building Walking Bass Lines*, this book approaches more advanced walking concepts, including model mapping, the two-feel, several "must know changes," and other important jazz bass lessons.

00695026 Book/CD Pack$19.95

Muted Grooves
by Josquin des Pres

Develop the string muting, string raking, and right-hand techniques used by the greatest legends of bass with this comprehensive exercise book. It includes over 100 practical exercises with audio accompaniments for each.

00696554 Book/Cassette Pack$12.95
00696555 Book/CD Pack$14.95

Slap Bass Essentials
by Josquin des Pres and Bunny Brunel

This book/audio pack includes over 140 essential patterns and exercises covering every aspect of slap bass, written by two of today's hottest bass players Josquin des Pres and Bunny Brumell.

00696563 Book/CD Pack$14.95